COUNTY FAIR

LIZA GERSHMAN

COUNTY FAIR

NOSTALGIC BLUE RIBBON RECIPES FROM AMERICA'S SMALL TOWNS

Pies and cakes, jams and jellies, pickles, preserves, and sweets

images
Publishing

For my parents,
Nancy and Arthur Gershman,
for instilling in me a great love for the
preservation of everything nostalgic,
including county fairs.

CONTENTS

1906 *The year the Louisiana State Fair was founded.*

1918 *The first year the Louisiana State Fair was canceled. The reason was due to the global influenza epidemic.*

$24 million *Estimated annual economic impact of the state fair by LSUS Center for Business and Economic Research.*

400,000 *The average number of annual visitors to the state fair.*

50 percent *The number of Louisiana attendees to the state fair annually.*

35,000 *The number of corn dogs sold each year at the state fair.*

4,500 *Livestock animal entries exceeds this figure each year at the state fair.*

INTRODUCTION

I am, and have always been, a chronicler of vanishing things. I feel an urgency to record beauty in what I think will be no more, and to celebrate the poignancy of those cherished bits of culture. Small town life, and the American hamlet, remind me of a simple time when a slower pace was the norm, people were—for better or worse—less connected to the macro and more connected to the micro world, and the dinner table was for conversations rather than consuming via smart-phone apps, emails, texts, and calls. I was barely out of childhood when life shifted, but I remember those pre–cell phone, pre-internet days with longing and awe.

It is easy to yearn for summer life all throughout the year, and longing for the excitement, competition, and simplicity of a county fair has been so well expressed by the many contributors throughout this book. The range of experience varies from fair to fair, county to county, and state to state; however, the overarching commonality between them all is the abundant joy in participation that contestants and organizers seem to share.

Fairs have always been a passion, and imagery of carnival games and Americana decorate my mind. The cacophony of the Big Top and the midway (packed full with myriad colorfully themed games, amusement rides, and food booths) entice visitors; the scents from the farm overwhelm; the sweetest pink cotton candy aromas wafting through the air. Certainly I've fallen in love at the fair, been amazed and awestruck by crafts, and delicacies, and the community coming together as one. It's easy to get lost in the pavilions and the carnival, and spend hours mesmerized by suckling pigs, horses racing, whirring Ferris wheels, hand-sewn quilts, homemade pies, and mouth-watering pieces of fudge.

I remember summer days sorting through jars of canned apricots, peaches, and plums. My parents were city people who embraced a country move in the 1970s, and fell into a love affair with California's Sonoma County Fair, welcoming country life with open arms. As a young girl I entered photography contests, and learned a rudimentary way to sew something for the pavilion. My mother excelled in painting (Best of Show), and won at the state fair level, too. We even volunteered at the House of Flowers, the pinnacle of competitive garden delights, and helped to paint the Yellow Brick Road for a *Wizard of Oz* theme. Even when we didn't enter prize competitions, ritualistically, each July we'd embark on a visit to our beloved county fair.

Oddly enough, researching this manuscript might have been easier in the days before the internet when one could thumb through white pages of a phonebook for any state, county, and town, while sitting in a dusty wood-armed leather chair at a dimly lit library. A librarian could shuffle through filing drawers, and pull out long rows of index cards and come to your assistance via the brilliantly devised Dewey Decimal System, and helpfully aid you by locating the name and contact number for every small town fair chairperson across the United States; and it was most likely their home phone. One could ring up said person on any given day, and likely have a long and lovely chat. Those days are no more, and as much as I long for the times when people enjoyed communicating via phone, I also value the simplicity of interaction and knowing that (almost) everything you read was accurate and trustworthy. Now, online sites like Google and Pinterest lead to hundreds and thousands of searches, but not necessarily to the individuals whom you might actually want to connect with, and so rarely on the phone. I suppose I'm a bit old-fashioned, one foot always in the time before tech and one foot embracing the modern day. My generation— Generation X—teeter-totters on the 'then and now'. This, in part, is what draws me so deeply to the nostalgia of simpler times in life and ultimately to the yearning to chronicle county and state fairs.

—— HISTORY OF FAIRS ——

America's first 'fair' began in the historic town of York (in what is now Pennsylvania) in 1765, 11 years before the nation was founded, and was considered 'the liveliest days of the whole year,' serving as a two-day agricultural market. Fairs continued for the next half-century in a similar fashion until a New England resident, Elkana Watson, founded what is considered to be the first agricultural fair in America, the Massachusetts Cattle Show in 1811. This 'show' exhibited cattle, swine, oxen, and sheep for prize money. The popularity of the show spread, and over the next few decades fairs were developed around the region.

The first state fair debuted in 1841 in Syracuse, New York, with livestock and vegetable competitions. "[The year] 1916 was the start of something spectacular—it was the year of the first Midland Empire Fair [in Montana]. This fair promised to have the finest agricultural, livestock, and industrial exhibits ever seen," according to the Montana State Fair organizers. "With great excitement for this new endeavor, the fair board made special arrangements with the Northern Pacific Railroad to run a train from the depot to the fairgrounds. This arrangement gave special rates for riders of the train to travel back and forth from the fair to home."

In 1928, the York Fair stayed open for evenings and weekends, and in the 1930s, the midway added automobile racing and 'freak shows,' which drew enormous crowds.

World War II closed most fairs, however the York Fair remained open. Sadly, the impacts of Covid-19 led to many fairs shuttering their gates in 2020, and many may remain permanently closed.

WHY FAIRS MATTER

State and county fairs are enormous revenue generators for communities, employing hundreds to thousands of workers. Fairs rely on established resources, like hotel and truck companies, electricians, and more, circulating money throughout the community, generating tax revenue that supports local economies for many years to come.

In addition to the economic benefits the local community receives from hosting a fair, a community is woven together over the duration and planning and preparation of a fair. Fairs join communities and bring neighbors together from across county lines. Like most fairs in the United States with dispersed populations, the Montana State Fair Association explains: "The Midland Empire Fair brought together communities from all over Montana and Northern Wyoming. This allowed people to show off their projects they had been working on all year in hopes of winning a Blue Ribbon and some recognition."

Vicki Imperati, DCAS Inc. Administrative Operations Manager at the Dutchess County Fair has devoted almost three decades to her community. This tenure is a common theme among fair planners. "I began my career at the Dutchess County Fairgrounds 27 years ago. For me, there's no better place to work than within the fair industry. A fair is a yearly event where friendships are formed and where traditions are passed down between generations," Imperati fondly remarks. "Fairs create a positive experience by nurturing connections and giving people a sense of belonging like they are part of something that is unique and extraordinary. Memories are made at the fair. These are memories that everyone cherishes and are shared at the dinner table or at gatherings. Who doesn't have a fond memory of being at a fair?"

State fairs are a showcase of a state's primary agricultural product, fostering the development of the best of the best, and county fairs are an intrinsic part of small-town community life. Fairs are an essential aspect of community health as neighbors truly get to see and praise the hidden talents of new and old friends. In my town, a gentleman became famous for building an elaborate sculpture out of toothpicks, now housed in the Smithsonian museum. Who would have ever known that a quiet-looking man on the driveway next door was capable of creating such tremendous beauty, without the help of the county fair? Hidden talents and passions are showcased, livestock is developed to feed people, home cooks celebrated for what they traditionally do at home for their families and friends. Fairs showcase the best individuality, and that is really something very American.

Wendy Oaks, Nevada County Fair (California) Deputy Manager, has worked at her fair for more than 12 years; however, she's been attending the Nevada County Fair since she was a child. "My Dad served as CEO for 25 years and I have fond memories of spending time in the baked goods building during the fair with my Grandma, who was building superintendent for many years," Oaks remembers. "I love the Nevada County Fair because it's part of my family story, but

I also love that it represents a deeply rooted tradition in Nevada County and it is an event that brings the community together each year."

Ann-Michele Ames runs the Agricultural Exhibition Center at Fryeburg Fair, Maine. She notes: "The fair is truly a family event with displays, exhibits, and shows that appeal to all ages. We have a big focus on education and have demonstrations throughout the week. We strive to get young people to enter contests. (What better way to get the adults involved … have them come to the fair to see their children's accomplishments.) We have displays from libraries, commercial farms, small family farms, health care centers, and daycares, as well as about 450 people who enter individual items (e.g., Afghans, quilts, mittens, ceramics, photos, flowers, vegetables, etc.). My favorite time at the fair is when the local schools close for the day and their students come to the fair with their teachers. They most usually have some kind of a 'hunt' with questions the kids have to answer about things at the fair. I remember one year a student knocked on my door and said one of his questions was to name three varieties of apples. His answer was red, green, and candy. We all got a good laugh about that."

—— THE COMPETITION ——

The 1990s saw a shifting trend in fairs with decreased agricultural focus and an increase emerging with competitors in the food and home arts contests. "As the number of farm families has decreased, the agricultural aspect of most fairs has waned, but the home arts competitions, which include such things as breads, cakes, cookies, preserves, and canning, have flourished and grown," wrote C and Y Sagon for the *Washington Post*.

"With statistics showing fewer Americans eating meals at home and home cooking being replaced by something called 'home meal replacements' in the supermarkets, fair officials say the number of home cooks competing at the fair is up in nearly every category. Virginia State Fair director of programs, Lorene Blackwood, says about 400 people entered the food and crafts contests at the fair in 1989. By [1990] that number had more than doubled to 900."

Most fairs have entire baking competitions on a specific theme and of course, without question, one is sure to find innumerable apple pie competitions across the country. In Alaska cheesecake reigns supreme, and Maine is littered with blueberry contest after contest for the sweetest delight. Pies are so prolific in the fair baking scene that this could have been an entire book dedicated to the art of pie-making, but it would be so remiss not to include all the beautiful relishes, jams, jellies, and more that come from the culinary arts departments and truly showcase the regionality of a community.

"We don't tell bakers they can't use a mix because we don't want to make a liar out of anyone," says Blackwood. "But frankly, those who do use mixes, it usually shows up in the judging. The judges can tell who cooked from scratch." So how does one pie stand out from the next?

The best quality ingredients make an enormous difference in the quality of the food, and items like butter and chocolate always alter flavor. Dishes are also based on appearance. When in doubt, winning competitors make multiples and submit the best-looking batch. Some participants plan their entire summer around preparation for the fair and take winning the local competition very seriously.

The Missouri State Fair organizers aptly summarize the spirit of fair competitions: "Since the first [State] Fair in 1901, thousands of Missouri families have made the annual 'pilgrimage' to Sedalia. Despite numerous differences, the fair exhibitors of 1901 and today share an important common element. That common denominator is competition—the desire to put your efforts against your neighbor's best." Many fairs publish their own recipe books and these are a delight to thumb through; pages rich with local traditions and favorites like Southern Pecan Pie in Tennessee and Key Lime Pie in Florida. Most states have a traditional dish or fruit or dessert, and fairs celebrate each with gusto and excitement.

"Since the first state fair, the reward has been ribbons, premium money, and recognition. But the long-term effect of this healthy competition has been a steady improvement in Missouri's agriculture, agribusiness, domestic arts and, today, even fine arts," say the organizers.

What's equally noteworthy is that fairs are "a barometer of the state's economic health and a documentary of the history of [their] agriculture. The Missouri State Fair plays an essential role in keeping agriculture one of Missouri's top industries."

What's more significant than celebrating regional specialties and showcasing those who love to make them? Some of the nation's finest cooks are hiding behind closed doors. Fairs give an opportunity for neighbors to meet and convene in public and learn of the talents of those they have formerly only run into at the store.

"I have been associated with the fair, working my way from entrant to volunteer helper, to co-chairman to chairman over about 30 years [all with raising five children!]," exclaims Debby Payne of the Dutchess County Fair. For Payne, and many others, "the fair is a place when just the everyday baker, crafter, seamstress, or photographer can enter their item and have others appreciate it as well as find out if their items are Blue Ribbon worthy." That community sharing and celebration is the core essence of what makes a fair so wonderful. "It's been a learning experience for sure, seeing the fair from the outside and then the inside. I am still learning, even from a baker's point of view, seeing the entries and then listening to the judges critique the items. We are never too old to learn new things as long as we are open to them."

The excitement and buzz of walking through the grandstand buildings on opening day to see if you've won a ribbon is no less exciting than seeing your first book in print, or winning at an athletic competition. To win is to win, and to be praised for that accomplishment (for excelling at your passion and your craft) in front of your peers, is something that fairs in America have offered to communities for well over two hundred years.

"There is so much that is special and unique about our fair, I don't know where to even start. I have had the privilege of being with the fair since our 1993 fair," proudly remembers Jessie McLaughlin of the Spokane County (Interstate) Fair. "I serve as the Fair Coordinator for the fair and have the honor of spending the entire year planning for and executing the annual fair. I often say that I have the privilege of coordinating a 'small' 10-day party for about 200,000 of my closest friends. We are indeed that ... truly friends. From the superintendents who oversee the various departments at the fair (from sheep to floral—and everything in between) to the commercial and food vendors, I *love* it when we are together on the grounds in September. I refer to our relationship as 'fair family'. I've seen the children of our fair family grow up and some move on to take over their parents' business. I've seen the loss of others and cry each year when we publish our *In Memoriam* list ... their loss is always deeply felt. I've personally witnessed what this amazing 'fair family' does when another is down. One of our food booths burned down during a fair and the other vendors pitched in to replace equipment; even collecting donations to purchase food products needed to get them reopened. Time and time again, this 'fair family' amazes me with their kindness towards each other, towards us as a staff, and towards our beloved fair guests. In three words about what I love—*our fair family*."

Tawny Tesconi and her brother, Tim, have loved fairs since their first 4-H [Head, Heart, Hands, and Health program] entry in childhood. Now in their 60s, the duo carved out time to volunteer and have spent their life's work preserving the legacy of many fairs by serving on boards and working in the planning offices. "The summer of 2018? We fulfilled our long-time dream of going to the Minnesota State Fair. It's the largest fair in the country."

Fairs are more than competitions and rides. They are a place for communities to come together and share some of the most meaningful moments in life. "What makes us unique and special is that although surrounded by industrial businesses, we give our fair guests the opportunity to visit the past, present, and future once they arrive through our gates. We are a place that they can step away from the troubles of the world, spend time with their family and friends, and receive some agriculture education while they're here (as a side bonus)," shares Jessie McLaughlin of the Spokane County Fair. "Our fair dates always fall over September 11. In that fateful year with the tragic events in New York, we cried together, sat in disbelief asking 'how could this happen to our beautiful country,' and then we opened our fair gates. We didn't know if anyone would come that day. We just knew that we needed to provide an outlet for the families in our region to be together and remember better days. They came. What makes us unique? We are an annual tradition in our region, but I believe that we are much more: we are a family that comes together over 10 days in September to provide hope, joy, and memories to all that attend / participate in the Interstate Fair."

—— THE FUTURE OF FAIRS AND THE ECONOMIC IMPACT ——

For those of us deeply concerned that the Covid-19 pandemic of 2020 will be the end of many fairs, it's important to stay positive and resilient in our communities, and remember that millions of visitors attend American fairs annually, and even small county fairs, like the Meigs County Fair in Ohio, have survived the test of time and the struggles that come with any institution of more than 150 years. Established in 1851, Ohio's Meigs County Fair is a driver of economic activity, reflected in the idea: "culturally and socially significant is a celebration of a region's agricultural heritage," remarked Meredith Deliso for the ABC News. The Indiana State Fair, which [was] canceled [in 2020] typically "hires more than 1,000 seasonal employees," said the ABC News.

Fairs aren't simply a wonderful way to experience a summer day, or a community gathering place. They are a leading driver for local and regional economies. Local organizations like the Kiwanis club often receive donations from fair proceeds, and 4-H Families can make enough money from selling cows and pigs to pay for a year of school or food for the whole family. Fairs create a ripple effect of spending through a region in the form of hundreds to thousands of workers and carnival operators who patronize local restaurants, grocery stores, and hire local mechanical repair services through the set-up, duration, and break-down of the fair. Even local hotels suffer without fairs as tourists come from far and wide to participate. For example, in 2019, the Ohio State Fair had nearly one million attendees during the 12-day-long festivities. As of 2019, the Minnesota State Fair averaged 200,000 people per day for a grand total of 2,126,551 visitors, or 37 percent of the population of Minnesota visiting their fair.

Pandemic-ravaged 2020 had a significant financial impact on every community in America, and the unanticipated closure of fairs for 2020 and many for 2021 will take years to recover from. "The economic impact of canceling both Illinois state fairs in Springfield and Du Quoin is expected to be at least $80 million," reported Meredith Deliso, for ABC News affiliate WICS in Illinois. "The loss to the Des Moines tourism industry for canceling the Iowa State Fair has been estimated at $110 million, according to the Des Moines Register." The Wisconsin State Fair is the largest event in the state, drawing more than one million visitors. The economic hit of canceling that fair is estimated at more than $200 million, VISIT Milwaukee President and CEO Peggy Williams-Smith told the Milwaukee Journal Sentinel," ABC continued.

The closures of fairs across America, including permanent closures due to the effects of the global pandemic, will certainly lead to economic drought, and a decline in community morale. The tragedy of that is that fairs are so intrinsically linked to the fabric of who we are as an American society, and it remains to be seen what will exist when the local baker no longer has a place to shine, or the competitive quilter no longer has a need or an excuse to craft. I tear up when I think about this possibility, but I'm optimistic of the endurance of the American people. It is my sincere hope that this book reminds you of your love for your own fair, the nostalgia of childhood, and the value of celebrating local and regional Blue Ribbon award-winning cuisine.

Bless America, and bless the county fair.

THE PANTRY & THE DRAWER

This section lists the key ingredients, utensils, and equipment used regularly by the winning bakers and cooks when competing and showing at America's state and county fairs.

stocking the pantry Sourcing local ingredients is always the surest way to ensure fresh flavor. Many cities and towns have wonderful farmers markets with fresh and seasonal produce, berries, and fruits for pies and cakes, jams and jellies, pickles and preserves, and sweets. For dairy—the bakers aim to source all their butter, cream, and milk from local dairies who are committed to organic, non-GMO standards, where possible. A list of some of the essential ingredients:

baking powder

baking soda

butter (incl. unsalted butter)

buttermilk

chocolate (bars and chips)

cocoa powder

cream

dried shredded coconut

eggs

flour (incl. all-purpose, cake flour, and self-raising)

honey

milk

molasses

nuts (almonds, pecans, walnuts)

salt (kosher, pickling, and sea)

sugar (incl. brown sugar, granulated sugar, and powdered/confectioners' sugar)

vegetable oil or spray

yeast

bowls (mixing) It's easiest to work on baking recipes when you have a variety of mixing bowls. Small, medium, and large mixing bowls come in nesting sets at home stores or online and you can often find them at vintage shops as well. One never has too many small bowls to separate spices and dry goods, and the large bowl allows for easy mixing with a tool or hands.

brushes It is useful to have two brushes, one for wet projects like applying an egg mixture or syrups and one to brush away crumbs. Be sure to have pastry brushes separate from savory brushes because flavor tends to sink in, even on clean bristles, and you don't want garlic seeping into your sweet syrups. Have a 1-inch-wide brush (made with natural bristles) handy, for your baking projects.

baking sheets A standard baking sheet for cookies, bars, and meringues can be found at any supermarket, cooking store, or online.

cake pans These come in a variety of sizes, and the cakes in this book do well as 6-inch and 8-inch rounds. Use a 9-inch springform pan for cheesecakes.

cake racks Cake racks are designed for cooling cakes and baked goods. Wire racks are suggested for their non-stick functionality.

cake stands Revolving cake stands (with a spinning turntable) are an American invention and the easiest tool for frosting and decorating cakes.

cheesecloth or cloth (jelly) bag Very handy for straining liquid mixtures, especially fruit for jellies, or bundling spices and other aromatics.

cutting boards A variety of cutting boards are useful. Plastic cutting boards are commonly recommended by professional chefs. Plastic boards are durable and long-lasting and are easy to clean in a dishwasher or by hand. Wood boards are better on knives.

dish towels The 100 percent cotton 'flour sack' dish towels are inexpensive and useful.

double boiler The double boiler is often used when it comes to melting chocolate and the baker chooses not to use their microwave or doesn't have one. A double boiler is a heatproof top pan that nests on top of another pan filled with simmering water.

fine-meshed sieve Recipes in this book sieve everything from flour to juices.

food processor Use for grinding candies and nuts to prevent turning them to butter.

knife set Having the right knife will make all the difference, and having sharp blades will make preparing most of these recipes a cinch.

knife, serrated A serrated knife is the tool for cutting layers in cakes. The blade should be longer than the diameter of the cake, for example, for an 8-inch cake use a knife with a 10- or 12-inch blade.

loaf pans Standard loaf pans that are used for recipes in this book come in a 5x9-inch size.

measuring cups **dry-use** Are typically used for scooping your dry ingredients, allowing you to level off the measurement with a knife or straight-edge; **wet-use** Come in 1- to 2- to even 4-cup increments and are used for measuring milk, oil, and other wet ingredients. These feature a spout and measurements printed along the side so you can check your measurement at a glance.

measuring spoons These come in many sizes. Having a set or two is essential. Keep one for dry use and one for wet use.

microwave A microwave is the easiest way to melt chocolate and is useful for heating frosting to the right temperature as well.

mixer (electric handheld or stand mixer) A heavy-duty stand mixer with a 5-quart bowl and whisk and paddle attachments or a handheld mixer are best for making cakes.

parchment paper This is non-stick paper and is different from wax paper. A common use is to eliminate the need to grease sheet pans and provide for easy cleanup.

pastry-cutter wheel Used for cutting pastry dough (key for pie crust making). This tool can have a single wheel or two small wheels that are wooden or metal attached to a handle. Metal is easiest to use for pie crusts.

pickling and canning jars Ball-brand mason jars can be found at most hardware or craft stores and are standard for canning and preserving, as these withstand the higher temperatures of a pressure canner better than single-use jars, which can break. Best to preheat (sterilized) jars in the dishwasher or in simmering water prior to filling them and avoid heating jars in the oven. Don't overfill: leave a ¼-inch headspace for juices, jams and jellies, and relishes, and around a ¼–½ inch for fruits, tomatoes,

and pickles. Check for guidelines on the best methods for canning safely; there are usually different procedures for the boiling water bath, atmospheric steam canning, or pressure canning procedures.

pie dish The 9-inch is standard. Pie dishes come in a beautiful array of colors and designs and are a fantastic way to display your award-winning pie when serving.

rolling pin Use with canvas mat and rolling pin cover set. A patterned rolling pin makes intricate patterns on top of dough and is beautiful for sugar cookies.

scraper Use for getting the last morsel out of a bowl; a scraper is easier to use than a spatula.

silpats or silicone baking mats Recommended, but not required, these often take the place of parchment paper when preparing baking pans for cookies.

spatulas A variety of spatulas will come in handy to make the recipes in this book. Rubber spatulas are useful for turning out batter, folding in ingredients, and scraping sides of bowls (if you don't have a scraper). Metal spatulas are useful for lifting cake layers when decorating.

thermometers A cooking thermometer / candy thermometer is useful for many recipes in the book that call for specific temperatures at different stages in the recipe. Baking is a science and it is essential to get an accurate temperature in the process.

whisks These come in a variety of sizes and are used for everything from whisking together dry ingredients to beating heavy cream into whipped cream or blending a perfect cake batter.

STANDARD (ESSENTIAL) RECIPES

While unique recipes are always delightful, having a standard go-to for basic items can be a true blessing and timesaver. These essentials will guide you through many of the tasty pastries, confections, and canned goods in the book. You can always swap out your own standard family favorite in substitution for anything in this chapter and know that you will still have great success.

These essential recipes are grouped by type: cake; glaze and syrup; frosting and icing; whipped cream and meringue; candied fruit and nut; and pie and crust.

DEVIL'S FOOD CAKE

5⅔ cups sugar
5½ cups cake flour
1½ tbsp baking soda
¼ tbsp baking powder
2 cups vegetable oil
7½ eggs
4 cups water
1¼ cup cocoa powder

Yields two 9-inch

or three 6-inch basic chocolate cakes.

Preheat oven to 350°F. Sift dry ingredients together, except cocoa powder. Stir in vegetable oil, and then add eggs and water. Fold in sifted cocoa powder and stir to fully combine. Divide batter between two greased 9-inch cake pans, or three 6-inch cake pans. Lightly drop each pan onto the counter to settle the batter.

Bake at 350°F until the edges start to pull away from the pans, and the center springs back when touched lightly.

> The general rule with cake is that the thickness of the filling is half that of the cake, so if the main layer of the cake is 1 inch then generally the filling is a ½ inch.

VANILLA CAKE
AND BUTTERCREAM FROSTING

VANILLA CAKE

1 cup unsalted butter, softened

1 ½ cups granulated sugar

4 eggs, room temperature

1 tbsp vanilla extract

2¾ cups cake flour

2¾ tsp baking powder

½ tsp salt

1 cup whole milk, room temperature

BUTTERCREAM FROSTING

1½ cups unsalted butter, softened

5½ cups confectioners' sugar, sifted

1 tbsp vanilla extract

¼ tsp salt

6 tbsp heavy cream, room temperature

For the cake: Preheat oven to 350°F. Grease the sides and bottom of two 9-inch round cake pans, and cut to fit parchment paper to fit into the bottom of the pans. Dust the pans with flour, and tap out any excess. Set aside. In a large bowl, using a handheld or stand mixer, cream butter and sugar together until fluffy. Add eggs, one at a time, mixing well after each one. Add vanilla and beat to combine.

In a medium bowl, whisk together cake flour, baking powder, and salt. Slowly add it to butter mixture, followed by milk. Beat on medium-low speed until combined, being careful not to overmix.

Divide the batter evenly between prepared pans. Bake for 20–30 minutes or until a toothpick or knife inserted into the center comes out clean. Do not overbake, check halfway through and adjust timing if necessary.

Cool in the pans for 10 minutes, remove cakes and allow to finish cooling on a wire rack.

For the buttercream frosting: Using a stand mixer with the paddle attachment or a handheld electric mixer, beat butter in a large mixing bowl on medium-high speed until creamy and pale.

Slowly add half of the confectioners' sugar and beat on low speed just until the sugar is incorporated. Turn up the speed to medium-high and beat until completely combined, about 3–5 minutes. Add the remaining confectioners' sugar, mixing until incorporated, then again, turn up the speed and beat for another 3–5 minutes.

Add the vanilla extract and salt, and turn on the mixer to low speed, and slowly add half of the heavy cream. Turn up the mixer to medium-high and beat until the cream is well incorporated, scraping down the sides as you go.

Check the consistency of the frosting and add more cream, ½ tablespoon at a time until you reach your desired consistency. It should be soft and spreadable and able to hold its shape.

GLAZE

2 tbsp butter
1 cup powdered sugar
1 tsp vanilla extract, brandy, or bourbon
1–2 tbsp hot water

Melt butter in a 1-quart saucepan over low heat. Stir in powdered sugar and vanilla until combined. Beat in hot water, 1 teaspoon at a time until smoother and of desired consistency.

CREAM CHEESE FROSTING

½ cup butter, softened
8 oz cream cheese
2 tsp vanilla extract
4 cups confectioners' sugar, sifted

In a medium bowl, using an electric mixer or spatula, beat softened butter and cream cheese until well blended and fluffy. Add vanilla extract, stir to combine. Slowly add sifted confectioners' sugar and beat until creamy.

SIMPLE SYRUP

1 cup sugar
1 cup water

Mix in a small saucepan, and cook over medium heat, stirring constantly until sugar dissolves, being careful not to burn the mixture.

SEVEN-MINUTE FROSTING

1½ cups sugar
2 tbsp corn syrup
¼ cup water
6 egg whites

Combine ingredients in a bowl over a water bath on the stove. Cook to 160°F while whisking constantly, do not overcook. Put on a mixer with a whisk attachment and whisk until cooled and a medium to firm peak, frosting consistency.

ROYAL ICING

4 egg whites, beaten
4 cups powdered sugar
1 tsp lemon juice

Using an electric or stand mixer on high speed, beat eggs until foaming. Drop to low speed and gradually add powdered sugar, beating together until smooth and combined. Add lemon juice and beat on high speed until stiff peaks hold their shape, about 5–10 minutes. Royal icing sets hard to the consistency of a candy-like texture.

WHIPPED CREAM

2 cups heavy whipping cream
2 tbsp sugar
¼ tsp vanilla extract, brandy, or bourbon

Add all ingredients to a clean, dry bowl and beat vigorously until firm. A handheld electric mixer or stand mixer will make quick work of this.

Frosting can be applied slightly thicker than icing (which has more shine and is smoother), but the consistency of icing and frosting is not quite as thin as a glaze.

ITALIAN MERINGUE

You will need an electric mixer and a candy thermometer for this recipe.

4 large egg whites
¼ tsp cream of tartar
1¾ cups granulated sugar
¾ cup water
vanilla extract, or other flavoring (optional)

Using an electric mixer with a whip attachment, combine egg whites and cream of tartar. Separately, in a medium pot, combine sugar and water bring to a simmer over medium heat, stirring constantly. Once the syrup mixture comes to a simmer let rest (or use a candy thermometer and cook until the mixture is 230°F). If sugar crystals form on the sides of the pot, use a pastry brush dipped in cool water to dissolve. When temperature of sugar syrup is 230°F it's time to begin to whip egg whites on medium speed and form a froth by the time the egg mixture reaches 240°F. When the mixture is 240°F, turn the mixer to high speed and gently pour the syrup mixture into the mixer bowl where the egg whites and cream of tartar have been waiting. Once all the syrup mixture is incorporated into the bowl, continue to whip into desired shape (approximately 4–5 minutes for soft consistency, 5–7 minutes for medium, and 8–9 minutes for stiff peaks). Add in vanilla extract toward the end of mixing.

There are three kinds of meringue: French, Swiss, and Italian. Italian is the most labor intensive to make (you cook the sugar to a temperature and then you have to time this with the whipping egg whites), but it is the most beautiful. Italian meringue is made by beating egg whites to firm peaks, then slowly whisking in hot sugar syrup to produce a dense meringue that can be used to decorate and top baked items, and can also be used as a base for buttercream frosting.

CANDIED CITRUS SLICES

ice water
4 small oranges or lemons, or both
4 cups sugar, plus ½ cup for dusting
8 cups water, divided (4 cups / 4 cups)

Fill a large bowl with ice water and set aside. Slice your fruit with a very sharp knife or mandolin, about ⅛ in thick. Too thin, and you'll lose the flesh in the drying process, too thick and they will take forever to dry. Bring 4 cups of the water to a boil in a large saucepan, and add citrus slices, boiling for 2 minutes. Immediately place the slices in the ice bath and discard the pot of water.

In the same saucepan, bring the remaining 4 cups water and sugar to a boil, stirring constantly until the sugar is dissolved. Turn the heat to medium-low and add the citrus slices. Simmer for 45–60 minutes or until rinds are slightly translucent, swirling every 10–15 minutes to make sure they are evenly coated. Transfer slices to a cooling rack set over a large baking sheet. Let them sit for up to 24 hours or until dry. Coat the candied citrus slices in granulated sugar for an extra glittery effect. Use immediately or store in an airtight container for up to 1 month.

CANDIED (GLAZED) PECANS

6 tbsp brown sugar
½ tsp fine sea salt
¼ cup (½ stick) melted butter
2 cups (6 oz) pecan halves

Preheat oven to 350°F.

Line a baking sheet with parchment paper or a silicone baking mat. In a large bowl, mix brown sugar, salt, and melted butter until smooth. Add pecans and, using a wooden spoon, toss to thoroughly coat. Transfer coated pecans to a prepared baking sheet and spread into one layer and bake at 350°F for 10 minutes or until the nuts begin to smell toasted, stirring halfway through. Allow to cool fully.

Wonderful when used to garnish many of these desserts, and leftovers are heavenly on salads or by the handful for snacking. Feel free to add other spices such as thyme, rosemary, and cayenne pepper for an addictive addition to a cheese board or holiday spread.

PIE DOUGH

2½ cups all-purpose flour, plus more for dusting surfaces
1 tbsp granulated sugar
1 tsp table salt
2 sticks (8 oz) unsalted butter, very cold
½ cup ice water

Whisk together flour, sugar, and salt in a large, wide bowl. Chop butter into small bits and work into flour mixture using a pastry blender or your hands until the crumbs are the size of small peas. Gently fold in the ice water with a rubber spatula, and mix until it forms into a shaggy mass. Using clean hands, knead the mass just two or three times to form into a ball, being careful not to overwork the dough, or you will get a tough crust. Once you have the ball, divide dough in half, wrap each half in plastic, flatten to a disc-like shape and chill for at least an hour or up to two days. You can also freeze the dough in double-wrapped plastic for up to one or two months, defrosting in the refrigerator for a day.

GRAHAM CRACKER CRUST

Simply double this recipe for a double pie crust.

1¾ cups Graham cracker crumbs
¼ cup brown sugar
¼ cup unsalted butter, melted

Mix ingredients together until mixture has the consistency of wet sand. Press into a 9-inch pie dish or tart pan, using the back of a flat measuring cup or drinking glass to ensure a flat and even bottom. Bake at 375°F for 7 minutes before filling.

BLUE RIBBON RECIPES STATE BY STATE

What's not to love about homemade pies and cakes, jams and jellies, pickles, preserves, and sweets! Especially when they are the authentic, regional, real deal. Organized state by state, this nostalgic deep-dive through America's heartland and love affair with the state county fair is represented by these classic regional blue ribbon—winning recipes, many from the prizewinners themselves.

ORANGE CHIFFON CAKE

Inspired by Mrs. Donna M. Hayes
North Alabama State Fair, Alabama

6 egg yolks
1 cup plus ½ cup sugar
1 cup potato flour
2 tbsp baking powder or cornstarch
½ tsp salt
4 tbsp water
1 tbsp lemon juice
6 egg whites
1 cup orange juice
blackberries and orange slices, for garnish

This orange chiffon cake is gluten free.

Preheat oven to 300°F. Beat egg yolks, gradually add 1 cup sugar, a little at a time and beat well. Mix and sift dry ingredients; add to yolks, stirring until blended. Add water and beat thoroughly. Beat egg whites with lemon juice in a clean, dry bowl until stiff, but not dry; gently fold into cake mixture. Pour batter into ungreased 9-inch tube pan. Bake at 300°F for 1 hour. While cooling, mix orange juice and ½ cup sugar in a small bowl. When mostly cooled, invert cake onto your serving dish or cake stand and pour orange juice and sugar mixture over cake while still slightly warm. Add a few blackberries and sliced oranges on top, and sprinkle sifted confectioners' sugar over cake to garnish, and serve.

MAPLE-PUMPKIN CHEESECAKE

Inspired by Stephanie Pirot, Blue Ribbon Prize
Alaska State Fair, Alaska

CRUST

1¾ cups Graham cracker crumbs

¼ cup brown sugar

¼ cup unsalted butter, melted

FILLING

3 (8 oz) packages cream cheese

1 (14 oz) can sweetened condensed milk

1 (15 oz) can pumpkin

3 large eggs

¼ cup pure maple syrup

1½ tsp ground cinnamon

¼ tsp ground nutmeg

TOPPING

4 tsp cornstarch

2 tbsp water

2 tbsp unsalted butter, room temperature

½ cup pure maple syrup

½ cup golden raisins

1 cup coarsely chopped pecans

Preheat oven to 325°F. For the crust, grease a 9-inch springform pan using butter or cooking spray. Mix together Graham cracker crumbs and sugar, and stir in melted butter. Press into a 9-inch pie dish or tart pan, using the back of a flat measuring cup or drinking glass to ensure a flat and even bottom. Set aside.

In a large mixing bowl, combine cream cheese and sweetened condensed milk and, using a stand mixer or handheld mixer, beat until smooth and creamy. Fold in pumpkin and beat until thoroughly combined. Crack in eggs, one at a time, beating on low speed until combined. Stir in maple syrup, cinnamon, and nutmeg. Pour filling over prepared crust. Set pan on a baking sheet and bake for 90 minutes, or until the center is almost set. Cool in pan on a wire rack for 10 minutes, then run a knife along the edge of the pan to loosen the cheesecake and let cool for an hour more (or longer) until you can safely pop it out and transfer to your serving dish.

While cheesecake is cooling, mix cornstarch and water in a small bowl until smooth. Melt butter in a small saucepan over medium heat, slowly adding cornstarch mixture and maple syrup, stirring until combined. Bring to a boil and cook over a medium-high heat, stirring constantly, until thickened, 1–2 minutes. Remove from heat; stir in raisins and pecans. Set aside until cool to the touch.

Spoon topping evenly over cheesecake, coating the whole top of the cake. Refrigerate overnight before serving.

LEMON MERINGUE PIE

Sharon Campbell, Blue Ribbon Prize
Yavapai County Fair, Arizona

PIE CRUST
1 pie crust (recipe page 57)

FILLING
1½ cups sugar
1½ cups water
½ tsp salt
½ cup cornstarch
⅓ cups water to mix in with corn starch
4 egg yolks, slightly beaten
½ cup lemon juice
3 tbsp butter
1 tsp grated lemon peel

MERINGUE
4 egg whites
½ cup sugar
¼ tsp salt

It's fun to make this recipe into mini individual pies, too.

You'll need to pre-bake the pie crust.

For the filling, combine sugar, 1½ cups water, and salt in a saucepan. Heat to a boil. Mix cornstarch and ⅓ cup water to make a smooth paste. Add paste to boiling mixture gradually, stirring constantly. Cook until thick and clear. Remove from heat. Combine egg yolks and lemon juice, and stir in thickened mixture. Return to heat and cook, stirring constantly until mixture bubbles again. Remove from heat. Stir in butter and lemon peel. Cover and cool until lukewarm.

To make the meringue, add salt to egg whites and beat until frothy. Gradually add ½ cup sugar, beating until glossy peaks are formed.

The secret step that makes this filling heavenly: Stir 2 heaping tablespoons of meringue into lukewarm filling. Pour filling into prepared baked pie crust. Pile remaining meringue on top and spread lightly over filling, making sure to reach the edge of the crust (sealing it). Bake in a slow oven, 325°F, about 10 minutes or until lightly browned. Cool.

"This has been a family favorite for years and is so unique because of one simple addition to the filling of this pie that totally changes the texture and flavor of this pie. It is impossible to eat just one slice!"

—Sharon Campbell

Lemon meringue pie is one of the most beautiful visual sights. A well-made meringue delicately towers atop a brilliant yellow middle, above a light crust. Originating in France in the 1700s, lemon meringue first appeared in a cookbook by Menon, as a thick applesauce covered with meringue.

It wasn't until 1869 in the United States that the 'pie' transformed into the stiff layered custard, topped with meringue, and garnered its American name. This has been a long-time favorite of mine and when I think of this sweet and delicate dessert, I instantly conjure up memories of summer.

PEANUT BUTTER AND JAM BARS

Inspired by Gloria Rankin, Best of Show Prize
Conway County Fair, Conway County, Arkansas

*Inspired by Gloria Rankin's sweet twist on the American staple, PB & J sandwiches,
these Peanut Butter and Jam Bars are perfect to pair with a glass of milk. Use the standard
bar recipe for the base and add Gloria's gooey, mouthwatering toppings.*

½ cup granulated sugar

½ cup packed brown sugar

½ cup shortening

½ cup peanut butter

1 egg

1¼ cups all-purpose flour

¾ tsp baking soda

½ tsp baking powder

¾ cup raspberry jam

*Optional: drizzle our glaze (recipe page 52) over the
cooled bars before serving.*

Yields about 36 cookies.

Preheat oven to 350°F. Cream together sugars, shortening, peanut butter, and egg. Stir into the peanut butter mixture the flour, baking soda, and baking powder to create the dough for crust. Set aside 1 cup of dough. Press remaining dough into an ungreased baking sheet to create the bottom crust and spread with jam. Make small crumbles with the reserved dough and sprinkle over jam layer. Bake for 20 minutes, or until golden brown. Cool and cut into bars.

*"I love it. I look forward to the fair every year.
It is amazing to me what people can do."*

—Gloria Rankin

RASPBERRY CREAM-FILLED CAKE

Inspired by Lawana Whaley, Blue Ribbon Prize
Garland County Fair, Garland County, Arkansas

*Inspired by Lawana Whaley's Raspberry Cream–filled Cake, this twist on a fair classic
is perfect for any celebration. The light–pink frosting and additional raspberry filling
are beautiful compliments to Whaley's dense chocolate cake, aka Devil's Food Cake.*

3 layers chocolate cake (Devil's Food Cake recipe page 48)
simple syrup (recipe page 52) , with added raspberry-flavor
2 tsp raspberry liqueur
pink or red gel food coloring
raspberry jam (optional)
buttercream frosting (recipe page 49)
whipped cream (recipe page 53)
raspberries, for garnish

Bake three layers of chocolate cake, using our award-winning recipe. Add 2 teaspoons raspberry liqueur to each batter before baking. While still warm, brush all sides of each layer with raspberry flavored simple syrup, and leave to cool on cooling racks.

Prepare buttercream frosting. If desired, use pink or red gel food coloring to dye the cream to the desired level of pink.

Optional: add a thin layer of fresh raspberry jam to each cake layer before the buttercream layer. Alternate whipped cream and buttercream for a light and heavenly texture. Garnish cake with fresh raspberries on top.

APRICOT BARS

Inspired by Jill Moritz, Blue Ribbon Prize
Los Angeles County Fair, Los Angeles County, California

*Inspired by Jill Moritz's recipe, we've removed the coconut
and walnuts for a more traditional taste.*

2 cups all-purpose flour
¼ tsp baking powder
¾ cup butter
1 cup sugar
1 egg
½ tsp vanilla extract
12 oz jar apricot preserves

Preheat oven to 350°F. In a small bowl, whisk together flour and baking powder; set aside. In a large bowl, using a hand mixer or stand mixer, cream butter and sugar until fluffy, approximately 5–7 minutes. Beat in egg and vanilla. Gradually add flour and baking powder to creamed mixture, mixing well. Reserve one-third of dough and set aside. Press two-thirds of dough onto the bottom of a greased 13x9-inch baking pan. Spread with apricot preserves and crumble remaining dough over this layer. Bake for 30–35 minutes or until golden brown. Cool completely in pan on a wire rack. Cut into bars.

BANANA BREAD MUFFIN

Cindy S. Peterson, Blue Ribbon Prize
Sonoma County Fair, California

1½ cups flour, unbleached or all-purpose

1 tsp baking soda

¼ tsp salt

3 ripe bananas (1 cup) mashed

½ cup shortening (or Imperial margarine)

½ cup granulated sugar

½ cup dark brown sugar, packed

2 large eggs, slightly beaten

2 handfuls semisweet chocolate chips (optional)

½ cup chopped nuts (macadamia nuts)

2 handfuls fresh blueberries

Stir together flour, baking soda, and salt. Set aside. Mash the bananas with a fork. Cream shortening and sugars in an electric mixer on high until fluffy. Add beaten eggs, and mix on low. Add in all other ingredients by stirring—do not beat with mixer—bananas first, then flour mixture in three portions. Stir in chocolate chips, nuts, and/or blueberries, as desired. Pour into well-greased loaf pans, or use a ladle and spoon into paper muffin cups in muffin tins.

For one large loaf pan, bake at 350°F for about 1 hour. For three mini loaf pans, bake at 350°F for about 50 minutes. For 12 muffins, bake at 350°F for 40 minutes.

"I can't remember the exact year I won the Blue Ribbon for the Banana Bread, sometime in the 1990s, at the Sonoma County (Harvest) Fair. I was really excited. I'd been making the bread for my family and friends for a long time, and everyone suggested I enter it. So I did!

My sister gave me the recipe many years ago, from a friend of hers. It's a great way to use up 'dying' brown bananas! I modified the recipe, using Gold Medal unbleached flour, C&H dark brown sugar, and Imperial margarine. I also doubled the recipe, and made mini-loaves as presents. My husband Bruce suggested making muffins instead of bread (that had to be sliced), for ease of eating. They became more popular than the bread! Then he suggested adding Nestle semisweet chocolate chips to some of the muffins—wow—we all liked that. I also added chopped macadamia nuts, and those were popular, too. Adding blueberries hasn't been as successful—they have too much moisture, so I need to decrease the amount or use smaller-sized blueberries. I'm still working on that.

I gave the recipe to our friend who moved to London and was teaching cooking classes to her students. She translated the ingredients to metric measurements, and had all of her students learn how to make banana bread. So I guess we could say it's now International Banana Bread! I double the recipe and bake two large loaves or 24 muffins at the same time (half plain, half with chocolate chips). The bread and muffins freeze well."

—Cindy S. Peterson

GOLDEN SPICE CAKE WITH ORANGE BUTTER FROSTING

Inspired by Diane Davis, Second Place
Nevada County 'Harvest Fair,' Nevada County, California

GOLDEN SPICE CAKE

3 eggs

1¼ cups sugar

1 cup canned pumpkin

½ cup vegetable oil

⅓ cup water

1¾ cups sifted flour

1 tsp salt

¾ tsp baking soda

2 tsp cinnamon

1 tsp nutmeg

1 cup quick rolled oats, uncooked

ORANGE BUTTER FROSTING

2 tbsp butter, softened

2½ cups confectioners' sugar

3 tbsp orange juice

1 tsp grated orange peel

pinch of salt

For the cake, beat eggs until light and fluffy, gradually adding sugar until the mixture thickens and turns a bright yellow. With a rubber spatula, stir in pumpkin, oil, and water. In a medium bowl, whisk together flour, salt, baking soda, cinnamon, and nutmeg. Add to pumpkin mixture, thoroughly combining before stirring in the oats. Pour into a greased and floured 1½-quart cake pan. Bake at 350°F for 45 minutes. Loosen edges with knife or spatula. Cool 10 minutes, then invert onto your serving plate. Cool and top with Orange Butter Frosting.

To make the frosting, cream butter, and gradually add sugar, alternating with enough orange juice to make frosting the right consistency for spreading. Stir in orange peel and salt.

STRAWBERRY LILIES

Inspired by Anna Witt, Blue Ribbon Prize
Colorado State Fair, Colorado

1 cup butter, softened
3 oz cream cheese, softened
¼ cup granulated sugar
1 tsp vanilla extract
¼ tsp salt
2 cups Gold Medal flour
½ cup strawberry jam
½ cup powdered sugar, for dusting

Cream butter and cream cheese until well blended; slowly add granulated sugar and beat until smooth. Add vanilla and mix until combined. In a separate bowl, whisk the salt and flour together. Using a handheld or stand mixer on the lowest setting, slowly add the flour mixture to butter and cream cheese until well combined. Divide dough into four pieces. Wrap each piece tightly in a separate sheet of plastic wrap, and refrigerate for 2 hours.

Preheat oven to 375°F.

On a lightly floured surface, one ball at a time, roll dough out to ⅛-inch thick and cut with 2-inch round cookie cutter or drinking glass. Place rounds 1-inch apart on greased or parchment-lined cookie sheets. Spoon ¼ teaspoon of strawberry jam into the center of each round and spread an even and thin layer within ¼-inch of the edges. Using a thin spatula, fold the left and right sides into the middle to create the lily shape and press to seal, using a little water on your fingertip to do so if necessary. Bake for 7–11 minutes until the cookies are lightly golden. Cool on a wire rack. Dust cooled cookies with powdered sugar.

GINGERSNAPS

Durham Fair, Connecticut

¾ cup (1½ sticks) butter, softened

1 cup granulated sugar

1 egg

¼ cup molasses

2¼ cups all-purpose flour

¼ tsp salt

2 tsp baking soda

1 tsp ground ginger

1 tsp ground cinnamon

1 tsp ground cloves

¼ cup candied ginger, chopped (optional)

½ cup sugar, for rolling (we use half coarse sugar and half fine sugar to get a lovely crunchy texture on cookies)

Yields 48 gingersnaps.

Preheat oven to 350°F. In a medium bowl, using a stand or hand mixer, cream together butter and sugar. Slowly add egg and molasses and combine. In a separate bowl, whisk together flour, salt, baking soda, ginger, cinnamon, and cloves. Gradually add the dry ingredients to the wet and combine until a dough forms. If using, fold in the finely chopped candied ginger for an extra kick.

Shape dough into 1-inch balls. Roll in sugar until evenly coated. Set 2 inches apart on ungreased baking sheets. No need to flatten the balls, as they will spread as they bake. Bake for 11–13 minutes, or until set and tops are crackled. Dust with granulated sugar and cool on wire racks.

CANNED TOMATOES, WHOLE

Denise Deskiewicz, Best of Show Prize
Delaware State Fair, Delaware

30-plus fresh tomatoes (Early Girl used)
ice water
kosher salt
7 sterilized qt jars
new lids plus rings for jars (lids sterilized)
water bath canner

Bring a large pot of water to a boil. Place five to 10 tomatoes at a time in the water for 30 seconds to 1 minute, just until the skin starts to split. Take out and immediately put in ice water. Peel the skins off and core out the stems. Place whole in sterilized quart jars. Gently push down to force out any air and allow natural juices to escape. Place 1 teaspoon kosher salt into each jar. Clean jar rims. Put on lids and screw tops. Place in the boiling water bath and process for 20 minutes after the water comes back to a full boil. Remove and place on towel or rack to cool. Make sure jars are properly sealed. Allow to rest for 24 hours before storing in cool dark area.

LAURA BYRUM'S GRANDMA'S SPICED PEAR PRESERVES

Laura Byrum, Blue Ribbon Prize
Delaware State Fair, Delaware

3 lb Bartlett pears
1¼ cups water
1 lemon, juiced
5 cups sugar
1½ (heaped) tbsp Sauer's Cake Spice* or less to taste
½ tsp ground cloves
2 sterilized 1-pt jars, or 4 x ½-pt jars

If you can't find Sauer's Cake Spice, combine ground allspice, ground cinnamon, ground coriander, and ground nutmeg to taste.

Peel and core pears. Slice thinly and place in a large saucepan with water and lemon juice. Bring to a boil and simmer for 15 minutes or until pears are tender. Slowly add sugar and stir over low heat until sugar is dissolved. Add spices. Then simmer for 35–40 minutes or until mixture thickens and pears are translucent. Ladle into hot sterilized jars to within ⅛ inch of the top of the jar. (Completed jars should have ¼- to ½-inch head space.) Place on hot sterilized lids and lightly screw on jar rings. Put jars in a boiling water bath for 10 minutes. Remove and cool. This recipe is for approximately 1 quart of finished product that you can divide between 1-pint or ½-pint jars.

"My grandmom used to make these, only it took me years to figure out how to make them as well as she did. Whenever I would ask her, she would just say 'Oh, honey, you just slice up some pears with some sugar and spice, cook 'em down and jar 'em up.' She's no longer with us but I think of her on the farm every time I taste pear preserves."

— Laura Byrum

"High temperatures and sudden storms are sure signs that the 2012 Delaware State Fair is underway … Judging is done by two-person teams and takes place over a two-day period. By the end of the first day of Baked Goods, even the most experienced judges confess that they don't want to see another cookie for about a week. The volunteers who judge in culinary are either food service professionals or they have taken the training classes offered by the Maryland Association of Agricultural Fairs and Shows to gain the certification needed to judge."

—Dover Post

KEY LIME PIE

Inspired by Kasey Meek, Best of Show
Florida State Fair, Florida

2 cups Graham cracker crumbs
½ cup unsalted butter, melted
8 oz cream cheese, room temperature
¼ cup unsalted butter, room temperature
1 can (14 oz) sweetened condensed milk
⅔ cup Key lime juice (optional: added zest)
garnish with whipped cream (recipe page 53) or
Italian meringue (recipe page 54)

Preheat oven to 350°F. In a medium bowl, thoroughly combine Graham cracker crumbs and melted butter. Press mixture into the bottom and up the sides of a 9-inch pie dish. Bake crust at 350°F for 10 minutes, or until lightly browned. Set aside to cool.

Using a handheld or stand mixer, whip cream cheese until softened and add butter. Once blended, slowly add condensed milk and then add the Key lime juice. Combine until well blended, stopping to scrape the sides of the bowl as necessary.

Pour mixture into crust in pie plate, cover with plastic wrap, and refrigerate for at least 4 hours.

Garnish with whipped cream topping or Italian meringue, with lime zest.

In 2006, Key lime pie was designated Florida's official pie by the state legislature. Condensed milk, egg yolks, and the juice of tiny yellow Key limes, traditionally set inside of a Graham cracker crust topped with meringue make this a state favorite.

Most Floridians have a recipe for Key lime pie, and they all claim it is the authentic version. Naturally debates about the true Key lime recipe and preparation are prolific, and questions arise between the most earnest matters. What Floridians do agree on, though, is that the filling must be light yellow, with no added food coloring. Heated debates: Is one to use a Graham cracker crust, or a pastry crust? Does the top feature Italian meringue or whipped cream, or—dare we suggest—neither? Is the filling cooked or uncooked?

PEACH COBBLER

Inspired by Rosalie Thatcher, Blue Ribbon Prize
Georgia State Fair, Arlington, Georgia

4 cups (about 1½ lb), peeled and sliced peaches
2 cups sugar, or less to taste
4 oz (1 stick) butter
1 cup flour
2 tsp baking powder
¾ cup milk

Note: fresh peaches at the peak of the season will require less sugar. Though peeled peaches make for a more traditional cobbler, we love leaving the skin on for a rustic and more colorful dish.

Preheat the oven to 325°F. To peel the peaches: Bring a large saucepan of water to a boil. Prepare an ice bath. With a paring knife, slice a small 'X' into the bottom of each peach. Once water is boiling, place as many peaches as you can fit into the saucepan and poach for 2 minutes. Using a slotted spoon, transfer peaches to an ice bath for one minute to cool. This will allow you to easily peel off the skins in preparation for this recipe.

In a medium bowl, combine peach slices with 1 cup sugar (or less, depending on the season, see earlier note); set aside.

Place 1 stick of butter in a 9x13-inch baking dish and put in the oven until butter has melted. Once melted, swirl the pan to coat the edges and set aside.

Meanwhile, in a medium bowl, combine flour, remaining sugar, and baking powder. Slowly stir in milk and mix until batter is smooth and no lumps remain. Spoon peaches and any juices into the prepared baking dish, spoon batter on top, covering the peach mixture, creating portion sections. Bake the cobbler in a preheated oven for 50–60 minutes, until light brown and bubbling. Transfer the pan to a wire rack to cool slightly. Serve warm.

When I think of Georgia, nicknamed the Peach State,
I cannot help but think of Peach Cobbler. Only in season for a
mere 16 weeks from mid-May through August, the peach is the
quintessential Southern fair fruit. Georgians will tell you that
a cobbler is something they've just 'thrown together' from
ingredients on hand in the house, but a discerning palate will
know that each and every cobbler maker has perfected
their recipe, and most likely it's been in the maker's family
for many generations, like the one shared earlier.

Not to be confused with a crumble or a crisp, which have oats
on the topping, a cobbler is similar to a thick-crusted pie
and is best served on a summer night, warm,
with a scoop of vanilla ice cream.

SOUTHERN LAYER CAKE / PRIZE CAKE

Inspired by Emma Lane, Blue Ribbon Prize
Columbus County Fair, Georgia

When Emma Lane first baked her cake and entered it into the 1898 county fair, she could not possibly have imagined the impact one kitchen–sink recipe would have on Southern culture. Popularized and served ubiquitously at social gatherings around the South, this cake originally published in Emma Lane's book, Some Good Things to Eat *(1898), won First Prize at the county fair and took the South by storm. A long–standing tradition ever since, the 'Prize Cake,' which became 'Lane Cake' and then 'Southern Layer Cake' is the most traditional fair recipe. Filling varies from region to region and state to state, and substituting some of your locally grown ingredients is the perfect way to make this a family favorite in your home. Some home bakers add in chopped apples and cinnamon, while others prefer raisins and apple brandy. (Our version is amended from Emma's original to include a cake filling of fruit and whiskey, with dried peaches and orange juice for color.)*

CAKE
Vanilla cake (recipe page 49)

FILLING
1 cup bourbon (whiskey) or brandy (or other alcohol of choice) or grape juice
½ cup orange juice
8 egg yolks
1 tsp vanilla extract
1½ cups sugar
½ cup butter, room temperature
1 cup dried peaches, finely chopped
1 cup pecans, finely chopped

Seven-Minute Frosting (recipe page 52)

The night before: for the filling, soak peaches in ½ cup orange juice and 1 cup bourbon.

Make the vanilla cake into four layers. In a bowl, beat egg yolks well. Add vanilla, liquid from soaked peaches (set peaches aside) sugar, and butter to egg yolks and continue to mix well. Put in a 2-quart saucepan and cook over medium heat; stirring constantly until thick (this might take as long as 15–20 minutes to get thick). When thickened, remove from heat and cool in refrigerator. Stir chopped peaches and pecans into cooled mixture. Cool slightly. Spread generously between each cake layer. Frost cake with Seven-Minute Frosting.

"I love the elements of nostalgia and tradition that the state fair holds for me. I grew up on a dairy farm in North Central Minnesota. The county fair was a big event at the end of the summer. My dad was on the fair board; my sister and I were 4-H members, which meant we exhibited items we had made. A purple ribbon at the county fair earned lucky winners a trip to the state fair. I have fond memories of staying in the 4-H dorms and exploring the fairgrounds with new friends from dawn to dusk. When my husband and I got married 37 years ago, going to the state fair became an annual tradition (only interrupted by [the unusual year] in 2020!).

I started exhibiting as an adult in 2010. I was diagnosed with cancer in 2008, and after going through a couple of pretty difficult years I needed something positive to focus on. I love baking so decided entering baked goods at the state fair would be fun. I started small that first year, winning second place for banana muffins. I have accumulated almost 30 ribbons since then. By 2012, I decided to dip my toe into the pie-baking competition; I have won six Blue (first place) ribbons, two red (second place), one white (third place), and four purple (sweepstakes) ribbons for my pies over the years. It has become a year-round hobby for me now. Planning for the next year begins almost as soon as the fair ends. The premium book is published the first week in May; registration can begin. I try out possible entries on my co-workers and family. The Saturday before opening day, my husband and I load up all by entries and head to the fairgrounds. Then, we all anxiously await posting of results on the first day of the fair."

—Carol Marsh, Minnesota

PINA COLADA CREAM PIE

Inspired by Kristine Snyder, Blue Ribbon Prize
Maui Pineapple Festival, Maui, Hawaii

PIE CRUST
Graham Cracker Crust (recipe page 57)

FILLING
⅔ cup sugar
5 tsp cornstarch
⅛ tsp salt
2 cans (8 oz each) crushed pineapple, with juice

TOPPING
3 tbsp cornstarch
3 tbsp flour
½ cup sugar
½ tsp salt
¾ cup non-alcoholic pina colada mix, divided into thirds
2¼ cups whole milk
1 egg plus 1 egg yolk, room temperature
1 tbsp unsalted butter, room temperature
1 tsp vanilla extract
½ cup heavy cream
shredded coconut, toasted

Preheat oven to 375°F. Bake pie crust for 7 minutes at 375°F and set aside. Increase oven temperature to 450°F.

For the filling: Combine sugar, cornstarch, and salt in a medium saucepan and stir in pineapple. Cook over medium-high heat, stirring constantly, until mixture thickens and begins to boil, about 8 minutes. Fill pie shell with the warm mixture and bake at 450°F for 9–14 minutes, or until filling is set. Cool completely.

For the topping: In a medium bowl, combine cornstarch, flour, sugar, and salt. Whisk in a third of the pina colada mix until smooth. Gradually whisk in milk and remaining pina colada mix. Transfer mixture to a medium saucepan and cook over medium heat, stirring frequently, until mixture thickens and begins a gentle boil, about 8 minutes. Remove pan from heat. In a medium bowl, beat egg and egg yolk until combined. Slowly stir in about 1 cup of the hot topping from the saucepan into egg mixture until well blended. Gradually pour egg mixture back into topping mixture still in the saucepan and cook over medium heat, stirring constantly, for 1 minute. Remove from heat and stir in butter and vanilla, until butter is melted. Transfer to a covered bowl and chill for 1 hour. Meanwhile, beat heavy cream in a chilled mixing bowl until stiff peaks form. Once topping has been chilled completely, gently fold in whipped cream. Spoon or pipe topping over pineapple filling in crust. Sprinkle toasted coconut evenly over top of pie. Refrigerate at least 1 hour before serving.

ZUCCHINI BROWNIES

Inspired by Desiree Wallace, Blue Ribbon Prize
North Bannock Fair, Pocatello, Idaho

Looking for something to do with your prolific summer crops? A way to sneak veggies into your kids via dessert? Try these chewy zucchini brownies and be surprised at how the zucchini melts away into chocolatey goodness. These brownies are moist and rich, and just might become your household favorite.

The secret to cooking with zucchini is in the size and the way you prepare the squash. Large zucchinis are dryer, and small zucchinis have moisture. Finer slices with a grater will be more inconspicuous, where coarse pieces will have a defined vegetable flavor and are better for breads. Remember that zucchini holds water and some recipes will call for pressing with a clean towel to soak up the added moisture. Here, the added moisture will enhance the brownies and pressing dry isn't suggested.

3 cups finely grated zucchini, undrained (one large zucchini)
2 cups all-purpose flour
1½ cups sugar
1½ tsp baking soda
1 tsp salt
½ cup unsweetened cocoa powder
1 egg
¼ cup neutral vegetable oil
2 tsp vanilla extract
1 pack (12 oz) chocolate chips

Yields 24 brownies.

Preheat oven to 350°F. Coat a 13x9x2-inch baking dish with cooking spray, butter, or parchment paper. Using a box grater or food processor, grate the zucchini into fine shreds. In a medium bowl, whisk together flour, sugar, baking soda, salt, and cocoa. Stir in the egg, oil, and vanilla. Fold in the grated zucchini and three-quarters of the chocolate chips until combined. Pour into the prepared baking dish, sprinkle remaining chocolate chips on top of batter, and bake for 45 minutes. Cool in pan on a wire rack. Cut into squares and serve.

TRIPLE CHOCOLATE REBEL COOKIES

Inspired by Toni McCue, Best of Show Prize
Sangamon County Fair, Sangamon County, Illinois

1 cup butter, softened
1½ cups sugar
1 egg
1½ cups flour
½ tsp baking soda
½ tsp salt
¼ cup cocoa
¼ cup water
1 tsp vanilla extract
1½ cups regular oats, uncooked
1 (12 oz) package semisweet chocolate morsels, divided

Using a handheld or stand mixer, cream butter and gradually add sugar and egg until thoroughly mixed.

In a separate bowl, combine flour, baking soda, salt, and cocoa. Add to butter mixture, a little at a time, while alternately mixing in the water. Stir in vanilla. Add oats and 1 cup of chocolate morsels, stirring to combine.

Drop dough by heaping spoonfuls onto ungreased cookie sheets. Bake at 350°F for 12–13 minutes. Let cool slightly on the cookie sheets before transferring to a wire rack to cool completely.

Meanwhile, melt remaining cup of chocolate morsels in a small bowl in the microwave or over a water bath on the stove. Drizzle melted chocolate across the cookies.

PEPPER RELISH

Laura H. Holman, Blue Ribbon Prize
Franklin County Fair, Franklin County, Illinois

ZUCCHINI CREAM PIE

From Suzanne Heiser's mother's recipe box via
Norma Malaby, a favorite cousin from Kokomo, Indiana
Indiana State Fair, Indiana

15 green sweet peppers
15 red sweet peppers
15 large white onions
1½ cups sugar
2½ tbsp salt
1 pt white vinegar
¼ tsp cayenne pepper

With a sharp knife, chop peppers and onions into fine slices, or put them through a food processor. Cover with boiling water; let stand 10 minutes. Drain. Add together sugar, salt, vinegar, and cayenne pepper and bring to a boil. Pack into sterilized jars and seal.

Pie crust (Graham Cracker Crust recipe page 57)
1 cup cooked zucchini
1 cup sugar
1 cup evaporated milk
2 tbsp flour
2 tbsp butter
1 egg
1 tsp vanilla extract
cinnamon or nutmeg to sprinkle on top

Preheat oven to 425°F. Purée zucchini and combine with other ingredients except sprinkle spices. Pour into an unbaked pie shell and sprinkle top with cinnamon or nutmeg. Bake 20 minutes at 425°F, then reduce oven heat to 350°F and continue to bake until done and the filling is set.

"I have fond memories of baking pie crusts with my mom. There were four very active kids in our family, and my parents belonged to church fellowships and service groups, and when food was given my mom always provided pie. For an entire day mother would make dough, roll it smooth, place it in a pie dish, and flute the edges of the crust over and over again. I bet she had a hundred of the exact same-sized metal pie pans, and between each crust she would layer waxed paper and stack the next on top. Leftover pieces of dough were rolled in cinnamon and sugar then baked, and those sweet treats were my reward for helping. When mother had made 10 to 20 crusts she would bag and seal the stack and freeze them until a pie was needed. A perfect, flaky crust could be removed one or two at a time as needed. Each season was a different filling: peach, strawberry, rhubarb, or zucchini. Zucchini cream pie is really delicious. [Mom] had more recipes for zucchini than anyone I ever met. Fall brought apple and pecan, and in the winter chess or custard pie was favored."

—Suzanne Heiser

CLASSIC APPLE PIE

Inspired by Teresa Winder, Blue Ribbon Prize
Johnson County Fair, Johnson County, Iowa

1 double pie crust for a 9-inch pie (recipe page 57)
5 Granny Smith apples, peeled, cored, and sliced ¼-inch thick
3 Golden Delicious apples, peeled, cored and sliced about ¼-inch thick
1 tsp lemon zest
1 tbsp lemon juice
¾ cup plus 1 tbsp sugar
2 tbsp flour
¼ tsp salt
¼ tsp nutmeg
1½ tsp cinnamon
1 egg white, lightly beaten

For the filling, place a large-rimmed baking sheet on the bottom rack of the oven and preheat oven to 500°F. Toss the apples with the lemon juice and zest. Combine ¾ cup sugar, flour, salt and spices in a small mixing bowl. Add the mixture to the apples and toss to coat the apples, and set aside while preparing the double pie crust.

Layer the apples into the unbaked pie crust bottom mounding them slightly in the center. Be sure to layer so apples overlap. Place excess juice from apples into a microwave safe bowl and cook on high for 1–2 minutes until thickened. Spoon thickened juice over the apples, covering them thoroughly. Cover filling with the top crust and seal and crimp the edges. Cut vents in the top crust, or cut a pattern, and then thoroughly brush with egg white, and sprinkle with the remaining 1 tablespoon sugar.

Iowa, known for lush endless rows of corn fields, welcoming folk, and Field of Dreams is a quintessentially American midwestern state. When I think about driving across the quiet, bucolic landscape of Iowa, dappled with small towns, I think of a nostalgic time in our country, and yearn for heart-warming recipes. President Hoover, Johnny Cash, John Wayne ,and Donna Reed all came from here. It doesn't get more American than Iowa, and a classic apple pie.

PEACH-ORANGE PIE

Inspired by Katy Reed, Blue Ribbon Prize
Johnson County Fair, Johnson County, Iowa

1 double pie crust for a 9-inch pie (recipe page 57)
4 cups peeled, sliced fresh peaches
2 large oranges, peeled and sectioned (about ⅔ cup)
¾ cup sugar
1 tsp orange peel, shredded
2 tbsp flour
2 tbsp butter, chilled

To peel the peaches, bring a large saucepan of water to a boil. Prepare an ice bath. With a paring knife, slice a small 'X' into the bottom of each peach. Once water is boiling, place as many peaches as you can fit into the saucepan and poach for 2 minutes. Using a slotted spoon, transfer peaches to an ice bath for one minute to cool. This will allow you to easily peel off the skins in preparation for this recipe.

Preheat oven to 375°F.

Poach and peel your peaches, placing into a large bowl with the orange sections. Add sugar, orange peel, and flour; stir gently to coat the fruit.

Prepare pie crust, and pour the filling into the prepared crust. Dot with 2 tablespoons of cold butter pieces. Cover with the top crust (lattice looks beautiful), trim, and crimp to seal. Slice a pretty pattern into the top to vent.

Cover pie with a sheet of aluminum foil and bake for 30 minutes. Remove foil and bake for an additional 30–40 minutes. Cool and serve with whipped cream or vanilla ice cream.

ANGEL FOOD CAKE

Inspired by Shelby Schultz, Grand Champion Prize
Grant County Fair, Kansas
and Mrs. Lola Young, Almena, Kansas
Rooks County Fair, Kansas

The Grand Champion award at a county fair is the highest honor a home-chef can win.
This recipe amends Shelby Schultz and Lola Young's Angel Food Cake, adding layers of fresh raspberries,
blueberries and strawberries to the filling and top for a red, white, and blue all-American twist.

1¼ cups sifted cake flour
1½ cups sifted powdered sugar
1½ cups egg whites (approximately 12–14 eggs),
room temperature
¼ tsp salt
1 ¼ tsp cream of tartar
¼ tsp almond extract
1 tsp vanilla extract
1 cup plus 2 tbsp granulated sugar
2 cups whipped cream (recipe page 53) plus
2 tbsp sugar plus ¼ tsp vanilla extract
handful of fresh berries

Preheat oven to 375°F. In a medium bowl, sift flour and powdered sugar together three times. In a large, very clean glass or stainless-steel bowl, combine egg whites, salt, cream of tartar, and almond extract. Beat with a handheld mixer or stand mixer until moist peaks form. Gradually add one cup of granulated sugar in two tablespoon increments, beating until blended each time. Add the vanilla extract. Continue beating until the meringue is able to hold stiff, straight peaks. Sprinkle the flour/sugar mixture three tablespoons at a time over the meringue, folding in gently with a rubber spatula until the flour/sugar mixture just disappears. Rinse a 10x4-inch tube pan with cold water, shaking out any excess water. Push batter gently against the tube and sides, filling the pan. Run a knife through the batter a couple of times to remove any air bubbles. Bake on the lowest oven rack at 375°F for 40 minutes and cool upside down in the pan on a funnel or bottle to prevent cake from shrinking or falling.

Once completely cooled, remove cake from pan and slice horizontally to create three layers. Assemble the cake, spreading whipped cream and berries between each layer. Frost the cake using whipped cream and garnish with fresh berries.

Famed around the world for its cinematic debut in the **Wizard of Oz***, Dorothy's "no place like home," Kansas borders Nebraska, Missouri, Oklahoma, and Colorado.*
The Sunflower State is one of the most bountiful agricultural states in the United States and the perfect place to visit a local fair.

LEMON CRUMB MUFFINS WITH LEMON GLAZE

Inspired by Mika Schultz, Purple Ribbon Prize
Grant County Fair, Grant County, Kansas

CRUMB TOPPING

1 cup all-purpose flour

1 tbsp granulated sugar

1 tbsp brown sugar

½ cup unsalted butter, melted

BATTER

¼ cup unsalted butter, softened

½ cup granulated sugar

1 large egg

½ tsp vanilla extract

zest of 1 lemon

2 tbsp lemon juice, freshly squeezed

1 cup all-purpose flour

¼ tsp salt

1 tsp baking powder

½ cup sour cream

GLAZE

6 tbsp powdered sugar

1 tbsp of lemon juice

Preheat oven to 350°F. Line muffin pan with muffin paper liners.

To prepare the crumb topping, whisk together dry ingredients in a medium bowl. Meanwhile, melt butter in a separate medium bowl, and slowly add dry ingredients to melted butter. Use a fork to mix until small pea-sized pieces form. Transfer crumb topping to a small-rimmed baking sheet or large plate and set aside.

In a large bowl cream together butter and granulated sugar. Add egg, mixing until fully combined, followed by vanilla, lemon zest and lemon juice. In a separate bowl, whisk together flour, salt, and baking powder, and fold into the creamed mixture, and mix until fully combined. Stir in sour cream and mix until no streaks remain. Use a large cookie scoop or ice cream scoop to divide batter between prepared baking cups. Generously coat each cup of batter with prepared crumb topping.

Bake for 18–20 minutes. Cool in pan until easy to handle, and transfer to a wire rack to cool completely.

As muffins are cooling, prepare the glaze. In a small bowl, whisk together powdered sugar and lemon juice. Use a small spoon or whisk to drizzle over cooled muffins.

CHOCOLATE BOURBON BALL CAKE WITH BUTTERCREAM AND PRALINE CRUNCH FROSTING

Inspired by Barbara Alt, Purple Ribbon Prize
Kentucky State Fair, Kentucky

BOURBON CAKE
Chocolate cake (Devil's Food Cake recipe page 48)
2 tbsp bourbon

BUTTERCREAM FROSTING
(recipe page 49)

PRALINE CRUNCH FROSTING
1½ cups pecans, chopped and toasted
6 tbsp unsalted butter
1½ cups brown sugar, firmly packed
½ cup plus 1 tbsp whipping cream
1½ cups powdered sugar
1½ tsp vanilla extract

Though we have used our buttercream for this recipe, another variation calls for an elegant chocolate ganache between each layer and the outside of the cake.
We recommend you prepare the bourbon ball garnish the day before and freeze until ready to decorate your cake.

Make three layers of our chocolate cake and while the cake is still warm, brush the top, sides, and bottom of the layers with 2 tablespoons of bourbon.

While the cake is cooling, prepare your buttercream frosting and set aside.

For the praline crunch frosting: Roast pecans in a 350°F oven for 5–7 minutes or until golden brown, stirring once. Add butter, brown sugar, and cream to a saucepan and bring to a boil over medium heat, stirring often, for 1 minute. Avoid burning. Remove from heat and whisk in powdered sugar and vanilla until smooth. Add toasted pecans and stir gently for 3 minutes or so until frosting begins to cool and thicken slightly. Set aside.

To assemble the chocolate bourbon ball cake: If necessary, level each cake layer by slicing off the domed top with a long, serrated knife. Place the first layer on a cake board or plate, and spread a small amount of buttercream evenly over the top of the layer, followed by approximately one-third of the praline crunch frosting. Place the second layer on top, and gently press the layer down. Spread an even layer of buttercream, followed by another one-third of praline crunch frosting, and press the third layer on top. Spread another layer of buttercream and the remaining praline crunch frosting. Put a crumb coat on the sides of the cake and refrigerate for 20 minutes. Frost with the remainder of buttercream and garnish with the bourbon balls.

BOURBON BALL GARNISH

15 whole pecans toasted, cut in half

4 tbsp unsalted butter, room temperature

2 cups confectioner's sugar, sifted

¼ tsp vanilla extract

⅛ tsp salt

¼ cup finely chopped pecans, toasted

2½ tbsp bourbon or to taste

2 cups chocolate chips

2 tsp shortening

For the bourbon ball garnish: Toast pecans in a 350°F oven for 5–7 minutes until golden brown. Prepare a baking sheet with parchment paper and set aside. Using a handheld or stand mixer, cream the butter, powdered sugar, and vanilla until fully combined. Mix in salt, finely chopped pecans, and bourbon. Refrigerate this mixture for at least one hour. Divide mixture in half, and leave half in the refrigerator while you work with the first half. Scoop mixture into marble-sized balls and place on your prepared baking sheet. Freeze sheet for at least one hour or overnight. In a small glass bowl, melt chocolate and shortening in microwave or over a saucepan of boiling water, stirring repeatedly until fully melted. If using the microwave, set the power at 50 percent (medium) and do not cook longer than 3 minutes, stirring the chocolate every 30 seconds until fully melted.

Prepare another baking sheet or plate with parchment paper. Take half of the bourbon balls out of the freezer and use a toothpick to dip the frozen balls in melted chocolate, placing each one on your prepared sheet. Top with a pecan half, if desired. Chill sheet in refrigerator until balls are set. Repeat with second half of balls.

*Bourbon is synonymous with Kentucky,
and bourbon balls are the dessert of the state.
Bourbon balls, created by Ruth Hanly Booe
of the nationally famous Rebecca Ruth Candy
empire in 1938, are a bite-sized bonbon filled
with dark chocolate and bourbon.*

DEWBERRY JAM

Inspired by Jaqueline Jones, Blue Ribbon Prize
Louisiana State Fair, Boyce, Louisiana

Inspired by Jaqueline Jones's winning recipe, this jam varies by region. In the South, dewberries grow in abundance, and in the North, cooks use blackberries for the same tart, irresistible taste.

3 qt dewberries or blackberries
1 (1¾ oz) box powdered pectin
7 cups sugar
4 sterilized 1-pt jars

Sterilize jars in the dishwasher and keep hot. Rinse and drain the berries. Mash or chop berries by hand or in a processor. Remove the seeds from half the berries using a sieve. In a large pot, put 5 cups of pulp and the pectin. Bring to a full boil, stirring constantly. As the mixture is boiling add in all the sugar and return to a boil for exactly 1 minute. Skim off the foam, fill jars to ¼ inch from the top. Wipe jars with clean cloth and place lids on jars. Screw on rims to finger tightness. Place jars on a rack in a canning pot. Cover jars with 1 inch of water. Process for 15 minutes in a simmering water bath.

DIXIE RELISH

Inspired by Maybeth Wilson
Louisiana State Fair, Marion, Louisiana

¼ cup pickling salt
2 qt cold water
2 cups chopped red bell peppers
2 cups chopped green bell peppers
2 cups chopped white onions
4 cups chopped cabbage
¾ cup sugar
¼ cup mustard seeds
2 tbsp celery seeds
4 cups cider vinegar
4 sterilized 1-pt jars

Dissolve salt in cold water in a large pot. Add peppers, onions, and cabbage to soak for 3 hours. Use a colander over a large bowl and drain the peppers, onions, and cabbage over a large bowl. In another bowl, combine sugar, mustard and celery seeds. Mix until sugar is dissolved. Pour sugar mixture over the vegetables and let sit overnight. The next morning, put jars and lids and rings into a dishwasher and keep until hot and sterilized. (If the jars are not hot and you add the hot mixture into the jars the glass will shatter.) Transfer vegetable mixture into a pot and bring to a boil, stirring once or twice. Turn off the heat. Take the jars out of the steaming dishwasher and place onto a clean towel on the counter. Ladle relish into the jars one at a time.

BLUEBERRY LATTICE BARS

Inspired by Debby Ayers, Blue Ribbon Prize
Union Fair & Blueberry Festival, Baileyville, Maine

Pie dough (recipe page 57)
3 cups fresh or frozen blueberries
1 cup sugar
3 tbsp cornstarch
¼ cup water

Divide dough in half; shape each into a 1-inch-thick rectangle. Wrap and refrigerate 2 hours or overnight.

Preheat oven to 375°F.

Place blueberries, sugar, and cornstarch in a small saucepan with ¼ cup of water. Bring to a boil over medium heat, stirring frequently; cook and stir until thickened, about 2 minutes. Cool slightly.

Roll each portion of dough between two sheets of waxed paper into a 14x10-inch rectangle and place on separate baking sheets; freeze until firm, about 10 minutes. Grease a 13x9-inch baking pan. Remove one sheet from the freezer, and press the rectangle of dough onto the bottom of your prepared pan and about a ½ inch up the side. Evenly spread the blueberry filling into the dough. Using a knife or decorative rolling cutter, cut the second rectangle into ½-inch stripes, and put back into the freezer to firm, about 10 minutes. Then arrange the strips over the filling in a crisscross lattice pattern. Press the edges with your fingers or a form to seal the strips. Bake for 30–35 minutes, until the top is golden brown. Cool on a wire rack and cut into bars.

"Since our area has an annual blueberry festival, my daughters and I are always looking for new berry recipes to enter in the cooking contest. These lovely, yummy bars won a Blue Ribbon one year."

—Debby Ayers

Maine is a breathtaking state. Quintessentially New England, Maine's early American roots are steeped throughout the culture, and blueberry festivals proliferate the summer season along the eastern shore. The official state food, the blueberry, a deliciously sweet indigo-colored button is a summer delight. Ripe for only a few weeks, the North American native berry was introduced to Europe for the first time in the 1930s.

ZUCCHINI BREAD WITH BROWN SUGAR OAT STREUSEL

Kevin McKenney, First Place
Maryland State Fair, Maryland

BROWN SUGAR OAT STREUSEL

⅔ cup old-fashioned or quick oats

½ cup packed sugar, light or dark brown

½ tsp ground cinnamon

2 tbsp all-purpose flour

¼ cup unsalted butter, cold

1 tbsp semisweet chocolate chips (optional)

ZUCCHINI BREAD

1½ cups all-purpose flour

½ tsp baking powder

½ tsp baking soda

½ tsp salt

2 tsp ground cinnamon

¼ tsp ground nutmeg

1 cup semisweet chocolate chips
(optional: chopped nuts, raisins, etc.)

½ cup vegetable oil (or melted coconut oil)

½ cup packed light or dark brown sugar

½ cup granulated sugar

1 large egg, room temperature

2 tsp pure vanilla extract

1 cup shredded zucchini (about 1 medium size)

Preheat the oven to 350°F and grease a 9×5- or 8×4-inch loaf pan.

To make the streusel: Combine the oats, brown sugar, cinnamon, and flour together in a medium bowl. Cut in the cold butter with two forks or a pastry cutter (preferred). Mix until the streusel resembles coarse crumbs. Stir in the chocolate chips. Set aside.

For the bread batter: Whisk the flour, baking powder, baking soda, salt, cinnamon, nutmeg, and chocolate chips (or nuts, raisins, etc.) together in a large bowl until thoroughly combined. Set aside. In a medium bowl, whisk the oil, brown sugar, granulated sugar, egg, vanilla, and zucchini together until combined. Pour into the dry ingredients. Gently whisk until *just* combined; do not overmix. Batter will be semi-thick.

Spread the batter into prepared loaf pan. Bake the bread for 20 minutes. Remove from the oven and sprinkle streusel on top. Using the back of a spoon, gently press the streusel down into the top of the loaf. The reason you are adding it after 20 minutes is to prevent it from sinking to the bottom of the bread as it bakes. Return bread to the oven and bake for an additional 25–30 minutes or until a toothpick inserted in the center comes out clean. If you notice the loaf is browning on top or on the edges too quickly, loosely tent the loaf with aluminum foil. Baking times vary so keep an eye on yours. Remove bread from the oven and set on a wire rack. Allow to cool completely before slicing.

APPLESAUCE BREAD

Mrs. Charles E. Cook, Middlefield, Massachusetts
Cummington Fair, Massachusetts

Marissa Jane Miller suggests serving this for teatime or breakfast.
"A simple cream cheese frosting (recipe page 52) could be quite nice with this."

2 cups sifted flour

1 tsp baking powder

1 tsp salt

1 tsp baking soda

1 tsp ground cinnamon

½ tsp ground nutmeg

½ cup shortening

¾ cup sugar

2 eggs

1 tsp vanilla extract

1 cup applesauce

½ cup walnuts, chopped (optional)

Preheat oven to 350°F. In a medium bowl, sift together dry ingredients (without the sugar). In a large bowl, using a handheld or stand mixer, cream shortening until smooth. Add sugar, beat until shortening and sugar are creamed. Gradually add the eggs and vanilla, and beat until combined. Add dry-ingredient mixture gradually, in thirds. Fold in applesauce and walnuts, mixing just enough to ensure blended thoroughly. Pour into a well-greased loaf pan. Let rise 20 minutes and bake in a 350°F degree oven for 55–60 minutes. Let cool and serve.

"*When my husband was young, he entered this zucchini bread recipe into the Maryland State Fair. It won First Place! If you make one zucchini bread recipe in your life, this has got to be it. It's beyond simple, makes great leftovers, freezes well, and can easily be doubled or tripled to make multiple loaves. (Simply double or triple each ingredient.) Use your bounty of zucchini this summer! Try this recipe as muffins, too.*"

—Sally McKenney

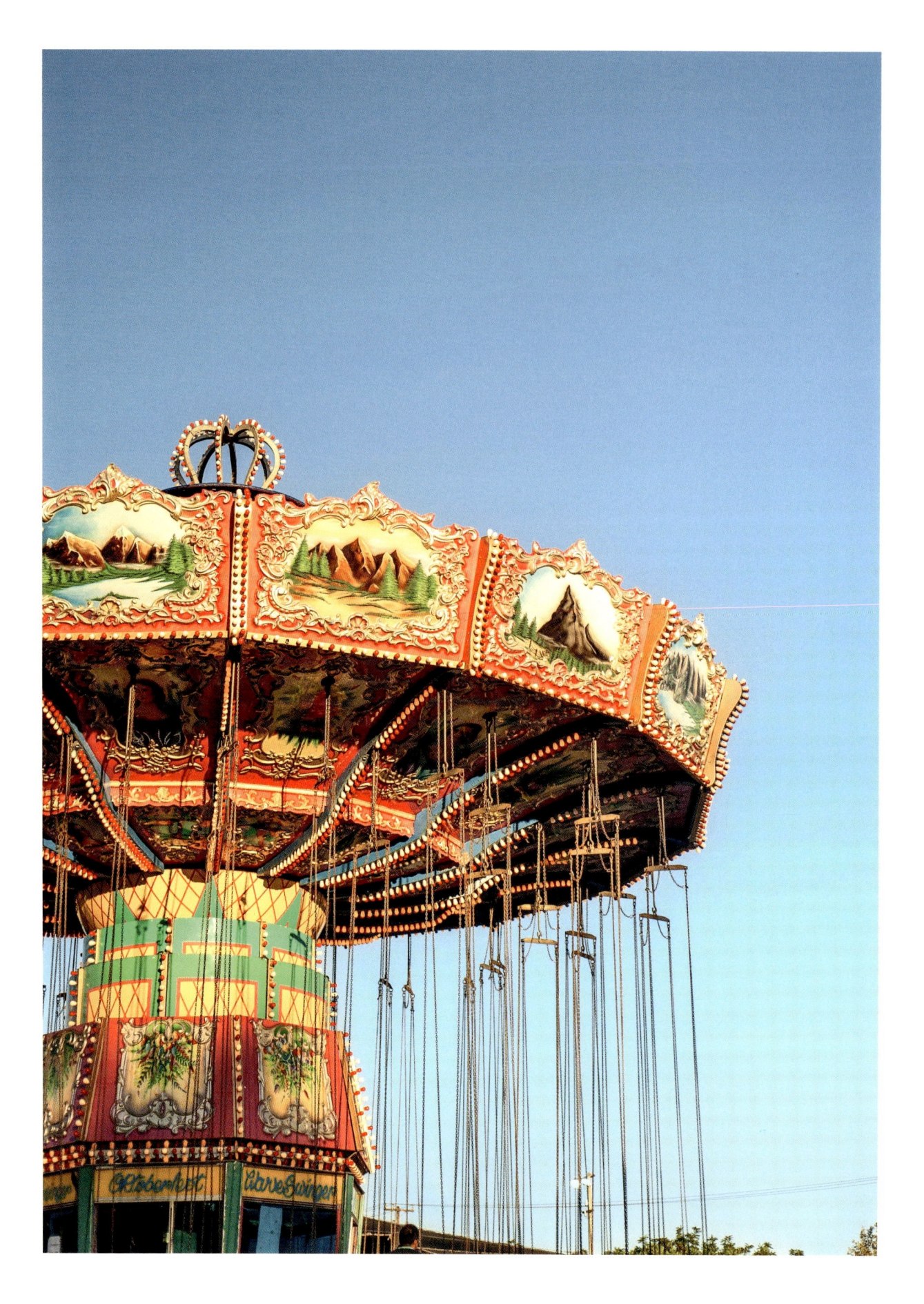

I've lived off and on in Massachusetts for the last decade, and love nothing more than New England small towns. Community in New England is very strong. Neighbors help neighbors survive harsh winters and summer is more glorious in New England than perhaps anywhere else in the United States. Though it's a short season (often not warm until July 4th, and chilly again come October 5), New England is glorious and a display of Americana at its best. Middlefield, established in 1780, is just one of those wonderful small towns that dot the Massachusetts landscape, rich with Revolutionary history and lore, sturdy and sweet and local, and the perfect choice to represent the state that I often call home. The Middlefield Fair [just a 30-minute drive from Cummington] has been hosted annually since 1855 by the Highland Agricultural Society, and is a small county-style fair, much beloved by locals.

FLUFFY ORANGE-COCONUT CAKE

Mrs. Robert E. Harper, Blue Ribbon Prize

Kalamazoo County Fair, Michigan

(This recipe also won ribbons at Barry County Fair and the Allegal County Fair, Michigan)

ORANGE-COCONUT CAKE

3½ cups cake flour, sifted

2 cups sugar

2 tbsp baking powder

1½ tsp salt

1 cup shortening

1½ cups milk

1 tsp vanilla extract

1 tsp orange extract

1 tsp grated orange rind

4 medium-sized eggs

Buttercream frosting (recipe page 49)

FILLING

1 cup sweetened condensed milk

1 cup sugar

3 egg yolks

1 stick margarine

1½ cups coconut

1 cup nuts, chopped

BUTTERCREAM ICING

½ cup butter

1 lb confectioners' sugar

½ cup milk

¼ tsp salt

1 tsp vanilla extract

½ tsp orange flavoring

½ tsp coconut flavoring

Yields 12–16 servings.

For the cake: Sift dry ingredients into bowl. Add shortening and milk. Beat at low speed to blend. Beat 2 minutes at medium speed. Add flavorings and rind. Add eggs, one at a time, beating after each addition. Beat at moderate speed 2 more minutes. Pour into two 9-inch pans. Bake for 30–35 minutes at 350°F. Allow to cool.

For the filling: Combine condensed milk, sugar, egg yolks, and margarine and bring to a boil. Continue cooking till thickened. Remove from heat. Add coconut and nuts. Cool.

To make the buttercream icing: Cream butter with sugar; add other ingredients, and any food coloring desired. To make a lighter-colored frosting that will take on a paler hue, use half butter and half shortening.

Spread filling between cake layers and frost with buttercream frosting.

BUTTERY PEACH TOFFEE PIE

Inspired by Emily Sibthorpe-Trittschler, Blue Ribbon Prize
Michigan State Fair, Michigan

Pie crust (Graham Cracker Crust recipe page 57)
5 cups sliced peaches
¾ cup sugar
3 tbsp flour
2 tbsp quick-cooking tapioca
1 tsp butter flavor
16 toffee candies

Preheat oven to 350°F. To make the filling: Combine peaches, sugar, flour, tapioca, and butter flavor. Grind the candies thoroughly in a food processor until crumbs. Stir crumbled candy into peach mixture. Line the bottom pie crust with mixture. Add top pie crust and seal. Cut vents in top crust. Bake for 45 minutes, or until golden brown.

APPLE PIE

Carol Marsh, Blue Ribbon Prize
Minnesota State Fair, Minnesota

Double pie crust (Graham Cracker Crust recipe page 57)

6 apples (3 Granny Smith, 3 Braeburn)

1 tbsp lemon juice

¾ cup granulated sugar, plus extra for sprinkling

2 tbsp flour

1 tsp ground cinnamon

⅛ tsp salt

1–2 tsp lemon zest

2 tbsp butter

1 egg white, beaten

Roll out half the dough and place in bottom of 9-inch glass pie plate. Chill while preparing filling ingredients. Peel and slice apples. Add lemon juice and toss to coat. In a separate bowl, combine sugar, flour, cinnamon, salt, and lemon zest. Whisk to mix. Add to sliced apples and toss to coat. Place half the apple mixture in prepared crust. Dot with 1 tablespoon of butter. Add remaining apples and dot with last tablespoon of butter. Add top crust. Seal, flute edge and vent top. Brush with beaten egg white and sprinkle with sugar. Bake at 375°F for 55–60 minutes, or until crust is golden brown and filling begins to bubble. Cover edges of crust with foil as needed to prevent excessive browning.

*"In May, the premium book comes out, and you can decide
what you want to enter. This year for the pies, there was the choice of
apple, mixed fruit, and peach, so I decided to enter a mixed fruit, and
apple pie … Two days before the entry day, I start measuring everything.
The weekend before the fair opens, you bring your entries down,
and you stand in line with all the other crazy people. You might wait
blocks in line in the heat. People bring coolers, people bring wagons.
My husband comes with me every year. It's very organized;
they take your entries and they judge them that afternoon,
and then there's the suspense of five days of waiting before you
can go online and find out if you won. It's fun.*

*"They judge pies on appearance, texture, flavor, and aroma.
You get a certain number of points for each category. And in each
pie category, there are 50, 60, or more pies entered. The winning pies
are displayed during the fair, but after a pie has been there for a week,
they don't look that good anymore.*

*"The peach raspberry pie is my favorite by far. When selecting fruits
for the mixed fruit pie lot, I knew I wanted to use my favorite—peaches!
My mom always taught me that food should not only taste great,
but should be beautiful as well. Color is so important.
Raspberries were the perfect choice. The flavors are a perfect blend
of sweet and tart. The brilliant colors and delicious taste of this
combination creates an edible work of art."*

—Carol Marsh

PEACH RASPBERRY PIE

Inspired by Carol Marsh, Blue Ribbon Prize
Minnesota State Fair, Minnesota

Double pie crust (Graham Cracker Crust recipe page 57)
4 cups sliced peaches
1 cup fresh raspberries
2 tsp lemon juice
1 cup sugar, plus extra for sprinkling
¼ cup ground tapioca (or flour, or cornstarch)
1 tbsp butter
1 egg white, beaten for egg wash

Roll out half the dough and place in bottom of a 9-inch glass pie plate. Chill while preparing filling ingredients. Add the peaches to a large, wide-mouthed bowl, and gently fold in the raspberries so that they are evenly distributed. Sprinkle lemon juice over the fruit and gently mix.

In a small bowl, mix sugar and tapioca and mix into the fruit. Fill the chilled crust and sprinkle small, pea-sized pieces of butter evenly on top of the fruit, and roll the top crust over the fruit.

Seal the edges by crimping the dough with your fingers, and slice a decorative vent into the top. Brush with egg white and sprinkle with sugar.

Bake at 375°F for 55–60 minutes or until crust is golden brown and filling begins to bubble. Cover with foil halfway through baking to prevent overbrowning. Let pie cool completely before serving. Serve with whipped cream or vanilla ice cream.

"I made my first pie when I was 18. My mother was out blueberry-picking, and I decided I could bake a pie, so I did. A few years later, I baked a pie for Braham Pie Days (a celebration of homemade pie in Braham, Minnesota), and it won a Blue Ribbon for a single-crust pie. So I started baking pies … I grew up west of Bemidji, in rural Minnesota, and the county fair was a big event. I didn't do a lot of baking then, but I sewed. So it was a nostalgic thing, when I thought about baking for the state fair. I learned that you didn't have to win at a local level to enter, so I started baking for the state fair about a decade ago."

—Carol Marsh

DILL BEAN PICKLES

Inspired by Veronica Wolkerstorfer, Maplewood, Minnesota
Minnesota State Fair, Minnesota

2 lb green beans, washed, trimmed to same length
4 heads fresh dill
4 cloves garlic
1 tsp cayenne pepper
2½ cups water
2½ cups distilled white vinegar
¼ cup pickling salt
4 sterilized 1-pt jars

Sterilize jars and lids in dishwasher and keep hot until needed. Place the beans vertically in hot jars, leaving ¼- to ½-inch room at the top. Add one head of dill, one clove of garlic, ¼ teaspoon cayenne pepper in each jar. In a kettle, combine water, vinegar, and salt. Heat to a boil. Fill jars with hot liquid leaving ¼- to ½-inch headspace. Wipe tops of jars with a clean towel, place lids and rims on to finger tightness. Place jars on rack in canning pot, cover with 1 inch of boiling water, process for 10 minutes. Wait two weeks to eat.

"Mom's bean pickles are a great favorite in the Wolkerstorfer family, where the children prefer them to buttered beans or to dill pickles. For a crisp product, pick beans at a slightly firmer stage than for eating and process immediately."

—Veronica Wolkerstorfer

BUTTERMILK BISCUITS

Inspired by Legendary Mississippi State Fair Buttermilk Biscuits
Mississippi State Fair, Mississippi

*According to the Mississippi State Fair, these Buttermilk Biscuits are 'legendary,'
and have been a staple part of the fair experience since the biscuit booth was introduced in the 1950s.
Auguster Lewis has been making biscuits at the state fair for 24 years. Sponsored by Kroger,
Prairie Farms Dairy and Blackburn Made Syrup (a Southern pantry staple since 1927, consisting of a
sweet blend of corn syrup and cane syrup), visitors are given a complimentary hot, homemade treat.*

4 cups self-rising flour (note: if using all-purpose flour, add 4½ tsp baking powder and 2 tsp salt to the dry mixture)
¾ cup shortening or salted butter
2 cups cold buttermilk

Preheat oven to 400°F. Grease a cookie sheet or cast-iron oven-safe pan with shortening or cooking spray. Pour the flour in a large bowl, digging a well in the middle. Add the shortening or butter in the well and using your hand, a fork, or pastry cutter, cut shortening into flour until the texture resembles a coarse cornmeal. Dig a well, and add buttermilk, stirring with a rubber spatula until a soft ball of dough forms. Be careful not to overwork the dough to avoid heavy biscuits. Lightly flour your work surface, and using your hands, pat the ball down to a ½-inch thickness. Using a biscuit cutter, 2-inch-round cookie cutter, or drinking glass, cut out round biscuits and place on your prepared baking sheet or pan. Bake at 400°F for 10–12 minutes or until light golden brown.

CHIP CHOCOLATE CHIPPERS

Inspired by Maxine Griggs, Blue Ribbon Prize
Missouri State Fair, Missouri

Maxine's original recipe added sour cream, oatmeal, as well as chocolate pudding.
Adding instant chocolate pudding mix to your batter is a fresh, unique take on a traditional classic,
creating a decadent fudgy cookie that will sure to please even the toughest cookie critic.

1 cup butter, room temperature

1¼ cups brown sugar (packed)

3.4 oz package instant chocolate pudding mix

2 large eggs

1 tsp vanilla extract

2 ¼ cups all-purpose flour

1 tsp baking soda

1 tsp baking powder

½ tsp salt

1½ cups semisweet chocolate chips

Preheat the oven to 350°F. Line baking sheets with parchment paper and set aside. In a large bowl, mix butter and sugar until creamed, then beat in the instant pudding mix until blended. Using a wooden spoon, stir in eggs and vanilla. Add in flour, baking soda, baking powder, and salt, and stir until combined. Fold in chocolate chips and gently stir until evenly distributed. Drop cookies onto the prepared baking sheets using a tablespoon. Bake for 10–12 minutes or until edges are set and the centers are still soft.

RED PEPPER JAM

Inspired by Anna Puckett, Blue Ribbon Prize
Midland Empire Fair, Lewiston, Montana

*I went to photography school in Montana, and have always held a sweet spot in my heart
and taste buds for everything from 'Big Sky Country'. I particularly love the tangy sweet bite of
Red Pepper Jam, and this simple recipe from Lewiston, Montana, relies on fresh red peppers.
Be sure to use peppers at the peak of the growing season for best results.*

8 oz jar
7 cups red sweet peppers, chopped
2 tbsp salt
6 cups sugar
4 cups vinegar

Sanitize an 8-oz canning jar and set aside. Wash and drain thick-walled peppers. (Fresh from the garden or farm market will be the most flavorful.) With a sharp knife, remove seeds and midribs and finely chop. Place in a large bowl. Mix chopped peppers with salt. Set aside and let stand 3–4 hours, then add sugar and vinegar and boil until mixture is thickened. Pour the boiling mixture into the sanitized jar, sealing at once.

COCONUT CAKE

Inspired by Teresa Reese, Blue Ribbon Prize
Nebraska State Fair, Nebraska

*This take on Teresa Reese's Coconut Cake from the Nebraska State Fair is perfect for afternoon tea.
Our cake uses light pink frosting to accent the beauty of fresh coconut topping, and the interior
layers of added filling are just the right amount of sweetness.*

Vanilla cake (recipe page 49)
Buttercream frosting (recipe page 49)
white gel food coloring
red gel food coloring
2½ cups shredded coconut
½ cup chopped pecans

Bake a 6-inch vanilla cake. Using a serrated knife with at least an 8- to 10-inch blade, slice the cake into three to four layers. Slice the dome off of the top of the cake to create a flat top. While your cake is baking, prepare buttercream frosting. Thoroughly mix in drops of white gel food coloring to turn the buttercream white, then add red gel food coloring until your desired shade of pink is achieved. Set frosting aside, keeping it slightly warmer than room temperature for ease of spreading onto your cake.

To assemble, place the first cake layer on your cake board or serving plate. Using a flat-bladed spatula, spread about ¾ cup of our buttercream frosting over the first cake layer and sprinkle with ½ cup of the shredded coconut and ¼ cup of the pecans. Add second cake layer, bottom side down, and spread with ¾ cup of frosting, covering with ½ cup of the coconut and remaining ¼ cup of the pecans. Add third cake layer, bottom side up and add a thin crumb cake on all sides of the cake to seal in the crumbs, preventing them from mixing into the decorative outer layer of frosting. Building the cake on a revolving cake stand, like a Lazy Susan, will make the final decorating of your cake much easier. Start with the sides, and working your way to the top, and using an offset spatula, evenly spread the remaining frosting over the cake, but because you are coating the cake in shredded coconut, it need not be perfect. Using a cupped hand, apply the shredded coconut to the sides and top of the cake, patting it gently to help it adhere. Carefully transfer the cake to your presentation platter and refrigerate for at least 1 hour and up to 8 hours. Remove from refrigerator 30 minutes prior to serving.

RHUBARB CAKE

Inspired by Suzanne Montero, Winnemucca, Nevada
Humboldt County Fair, Nevada

Use our cream cheese frosting (recipe page 52) to elevate this summertime classic.

RHUBARB SAUCE

1 lb rhubarb, cut into ½-in chunks (4 cups)

½ cup sugar

½ cup water

CAKE

3 cups sifted flour

4 tsp baking powder

½ tsp baking soda

1 tsp salt

1 tsp ground cinnamon

½ tsp each ground cloves, allspice, and nutmeg

1 cup shortening

1¾ cups brown sugar

4 eggs

1 cup rhubarb sauce (see recipe above)

¾ cup milk

½ cup each raisins and walnuts

For the rhubarb sauce: Chop rhubarb ribs into ½-inch chunks. In a medium saucepan, add rhubarb, sugar, and water, and cook until tender and liquid. Cool before using.

For the cake: Sift together flour, baking powder, soda, salt, and spices. Cream shortening and sugar until light. Add eggs; beat thoroughly. Stir in cooled rhubarb sauce. Add flour mixture to creamed mixture alternately with milk, mixing well after each addition. Fold in raisins and walnuts. Bake in two greased 9-inch pans. Bake at 350°F for 45 minutes.

CRANBERRY-RAISIN PIE

Ken Heckman, Blue Ribbon Prize
Deerfield Fair, New Hampshire

pastry for double-crust pie (Graham Cracker Crust recipe page 57)

3 cups fresh cranberries

2 tbsp flour

2 cups sugar

¼ tsp salt

⅔ cup water

1 cup seedless raisins

2 tsp grated lemon peel

2 tbsp butter

Remove stems from cranberries. Combine flour, sugar, and salt in a saucepan. Stir in cranberries, water, raisins, and lemon peel. Cover and lightly cook until cranberries start to pop; remove from heat and add butter. Cool until lukewarm.

Pour filling into 9-inch pie shell. Arrange top, and cut vents. Bake at 425°F for 40–50 minutes or until juices bubble in vents and crust is brown.

"The Deerfield Fair has always been part of our family culture. My mom and dad always had their duties at the fair, my mom as superintendent of the household building, both of them as members of the fair association, and their involvement in our church food booth.

My brother and I had free range of the fair as long as we checked in regularly at one of those two spots. The privilege of walking around the fair on your own is very much a rite of passage growing up in Deerfield. The only fair I ever missed was when I had my first son on the first day of the fair in 1998. I like to claim I didn't really miss the fair, though, because I was on the fairgrounds entering my vegetables to be judged when I went into labor!"

—Beth Heckman
(Superintendent of the Household Building [canned and baked goods])

"I got into making pies for the fair after my wife and I got married. As you know, the Deerfield Fair is a huge part of her family culture. So, as we were starting our own family, it naturally became part of our traditions as well.

Let me just say that cranberry-raisin pie is my dad's favorite, and a regular offering at Thanksgiving. One holiday I had offered to make it, and found a recipe in one of my grandmother's vintage 'country' cookbooks. I made two, one for each side of the family. Upon sampling, my mother-in-law, Carol, suggested I enter it in the fair. I did, and was awarded a Blue Ribbon. I was hooked.

I became a regular entrant after that—a different recipe every year from the antique cookbooks I started collecting. I often made up to four pies, entering the best looking and donating the others to the Deerfield Church Fair booth for fundraising.
A regular following developed there, eager to try that year's entry.

I even had friendly rivalries. My own teenage niece challenged me one year, boasting she could score higher than me. Of course, I had to respond. She won, scoring a Blue to my Red, but I've always suspected she had some help from my own mother.

That's pretty much the story of my ribbon-winning, fan-following, church-booth exclusive pie-making career."

—Ken Heckman

CHOCOLATE INFINITY COOKIES

Mike Morin, Blue Ribbon Prize
Deerfield Fair, New Hampshire

1 package premium bittersweet chocolate chips
6 tbsp unsalted butter
3 eggs
½ to ⅔ cup sugar
⅓ cup all-purpose flour
½ tsp baking powder
1 package semisweet chocolate chips
walnuts (optional)

Yields approximately 24 cookies.

Melt bittersweet chocolate chips and butter over a very low flame, or by using a double boiler. In a large bowl, cream together eggs and sugar, using a hand mixer or stand mixer. With a rubber spatula, fold in melted chocolate and butter mixture and stir to combine.

In small bowl, blend flour and baking powder, and add to wet ingredients, stirring to combine. Fold in semisweet chocolate chips and, if using, walnuts and mix gently.

Cover your workspace with a sheet of plastic wrap and form dough into two logs, approximately 8 inches long and 2 inches in diameter. Tie off both ends of each log and place in freezer for at least an hour, but no longer than 2 hours. If frozen, the batter will not slice easily.

Preheat oven to 375°F and remove dough from freezer. Unwrap and with a sharp knife, cut into ¾-inch slices. Arrange on parchment paper-lined cookie sheets. Bake for 10–13 minutes or until a shiny crust forms on top and inside is still soft. Pay attention during baking to prevent scorched bottoms. Cool on cookie sheet for a few minutes.

"As a career radio personality, I faced the pressure of interviewing presidents and celebrities. None of that compares to the nerve-wracking experience of entering a baking contest for New England's oldest family fair—the Deerfield Fair, established in 1876. Everyone adores this fair and lucky for me, the judges adored my Chocolate Infinity Cookies."

—Mike Morin

APPLE CAKE

Inspired by Kathy McGinniss, Blackwood, New Jersey
County 4-H Fair, New Jersey

3 cups flour, unsifted

2 cups sugar

1 cup vegetable oil

4 eggs

¼ cup orange or pineapple juice

2½ tsp vanilla extract

3 tsp baking powder

3–4 apples, sliced

2 tsp ground cinnamon, divided in half

8 tsp sugar, divided in half

Place flour, sugar, oil, eggs, juice, vanilla, and baking powder into a bowl in order given. Beat until smooth. Place half the batter into a well-greased tube pan. Arrange some apple slices on top of batter. Sprinkle with cinnamon and additional sugar. Pour in the rest of the batter and repeat apple slices and cinnamon and sugar. Bake in a 325°F degree oven for about 90 minutes. Cool in pan.

DILLED GREEN TOMATOES

Helen Kirsch, Albuquerque, New Mexico
New Mexico State Fair, New Mexico

WHISKEY SOUR COCKTAIL JELLY

Terry Sennett, Blue Ribbon Prize
Dutchess County Fair, New York State

6 sterilized 1-pt jars
72 (2–2½-in size) firm green tomatoes, washed
3½ cups distilled white vinegar
3½ cups water
¼ cup pickling salt
1 large green bell pepper, washed, seeded, cut in
12 (½-in) strips
1 large red bell pepper, washed, seeded, cut in
12 (½-in) strips
3 stalks celery, cut in 6 (4-in) pieces
6 cloves garlic
¾ cup (12 tbsp) dill seeds

6 tbsp bottled lemon juice
6 tbsp bottled lime juice
4¼ cups sugar
¼ cup bourbon
4–6 oz package ball liquid fruit pectin
5 maraschino cherries with stems
5 fresh orange slices

Thoroughly wash and scald six (1-pint) jars. Keep hot until needed. Prepare lids as manufacturer directs. Core tomatoes; set aside. In a medium-size saucepan, combine vinegar, water, and salt; bring to a boil. Pack about 10–12 tomatoes into each hot jar, leaving ½-inch headspace. Arrange two strips each of green and red bell peppers, 1 stick celery and 1 clove garlic in each jar so they are visible. Add 2 tablespoons of dill seeds to each jar. Pour boiling liquid over tomatoes, leaving ½-inch headspace. Wipe jar rims; seal with hot lids and screw bands. Process 15 minutes in a boiling water bath. Tomatoes are ready to eat in 4–6 weeks.

In a heavy pot, stir together the juices, sugar, and bourbon. Cook over high heat until the mixture comes to a full rolling boil, stirring constantly. Quickly stir in the pectin. Return to a full rolling boil; boil hard for 1 minute, stirring constantly. Remove from heat; quickly skim off foam with a metal spoon. Place one cherry and one orange slice in each hot, sterilized jar. Ladle hot jelly into jars, leaving ¼-inch headspace. Wipe jar rims; adjust lids and screw bands. Process filled jars in a boiling water canner for 5 minutes.

CHEWY PECAN BARS

Inspired by Barbara Creasman, First Place
Mountain State Fair, North Carolina

These chewy pecan bars, originally made by Barbara Creasman, are a traditional Southern dessert. Barbara's recipe has been amended to add a decadent praline crunch frosting covered with candied pecans for extra sweetness, decoration, and crunch.

½ cup butter
5 oz cream cheese, softened
16 oz light brown sugar
3 large eggs
1½ cups self-rising flour, sifted
½ tsp maple extract
½ tsp vanilla extract
1 cup chopped pecans, lightly toasted
Praline crunch frosting (recipe page 126)
1 lb pecan halves, candied (recipe page 56)

Preheat oven to 350°F. In a stand mixer, blend butter, cream cheese, and sugar until light and fluffy. Add eggs, one at a time, beating well after each addition. Add flour, blending well. Stir in maple and vanilla extracts. Stir in toasted pecans. Pour batter into a greased 13x9x2-inch pan. Bake for 30–35 minutes. Meanwhile, prepare the praline crunch frosting and set aside.

Prepare glazed (candied) pecans to decorate the top of your bars. Once the bars are cooled, spread a layer of praline crunch frosting over the top of the bars and press the glazed pecans into the top in a decorative fashion. Cut into 24–30 squares. (Leftover glazed pecans can be saved for up for a week in an airtight container and make a great addition to salads and snacks.)

RHUBARB-FILLED COOKIES

Inspired by Pauline Bondy, Blue Ribbon Prize
Upper Missouri Valley Fair, North Dakota

COOKIES

1 cup butter, softened

1 cup sugar

1 cup packed brown sugar

4 large eggs

4½ cups all-purpose flour

1 tsp baking soda

1 tsp salt

FILLING

3½ cups chopped fresh or frozen rhubarb (thawed)

1½ cups sugar

6 tbsp water, divided

¼ cup cornstarch

1 tsp vanilla extract

Note: as a substitution to enjoy summer year-round, use strawberry jam.

For the cookies: In a large bowl, cream butter and sugars until light and fluffy. Add eggs, one at a time, beating well after each addition. Combine the flour, baking soda, and salt; gradually add to creamed mixture and mix well. The dough will be sticky; use a rubber spatula to scrape down the sides of the bowl and gather into a rough ball.

For the filling: Combine rhubarb, sugar, and 2 tablespoons water in a large saucepan; bring to a boil. Reduce heat; simmer, uncovered, until thickened, stirring frequently, about 10 minutes. In a small, separate bowl, mix cornstarch, vanilla, and remaining water until smooth; stir into rhubarb mixture and bring to a boil, continuously stirring until thickened, about 2 minutes. Remove from heat and allow to cool.

Drop dough by tablespoonfuls 2 inches apart onto ungreased baking sheets. Using the end of a wooden spoon handle, make an indentation in the center of each cookie; fill with a rounded teaspoon of filling, and dot a little dollop of dough in the center of the filling. Bake at 375°F until lightly browned, 8–10 minutes.

"I won a Blue Ribbon at our local fair for these tender cookies. They're so pretty with the ruby–red filling peeking through the dough. Try making these special cookies and watch the smiles appear."

—Pauline Bondy

BLACK RASPBERRY BUBBLE RING CAKE

Inspired by Kila Frank, Grand Champion Prize
Meigs County Fair, Meigs County, Ohio

*This cake is a perfect breakfast choice. More like pull-apart-bread than true cake,
serve warm with a side of jam and butter.*

CAKE

1 package (¼ oz) active dry yeast
¼ cup warm water (110°F–115°F)
1 cup warm whole milk (110°F–115°F)
¼ cup plus 2 tbsp sugar, divided
½ cup butter, melted, divided
1 large egg, room temperature
1 tsp salt
4 cups all-purpose flour
1 jar (10 oz) seedless black raspberry preserves

SYRUP

⅓ cup corn syrup
2 tbsp butter, melted
½ tsp vanilla extract

In a large bowl, dissolve yeast in warm water, using a candy thermometer to ensure temperature remains between 110F° and 115F°. Allow it to sit for 5 minutes and then add the milk, ¼ cup sugar, ¼ cup butter egg, salt, and 3½ cups flour. Beat until smooth. Stir in enough remaining flour to form a soft dough. Turn onto a floured surface; knead until smooth and elastic, about 6–8 minutes. Place in a large, greased bowl, turning once to coat dough. Cover and let rise in a warm place until doubled, about 1¼ hours. Punch dough down. Turn onto a lightly floured surface; divide into 32 pieces using a knife or pastry scraper. Flatten each into a 3-inch disk. Drop about 1 teaspoon of preserves on the center of each piece; bring edges together and seal. Arrange 16 prepared dough balls in a greased 10-inch fluted tube pan. Brush with half the remaining butter; sprinkle with 1 tablespoon sugar. Top with remaining dough balls, butter, and sugar. Cover and let rise until doubled, about 35 minutes. Meanwhile, preheat oven to 350°F. Bake until golden brown, 25–30 minutes.

Combine syrup ingredients; pour over warm bread. Cool for 5 minutes before inverting onto a serving plate. Drizzle raspberry preserves on top prior to serving, garnish with fresh raspberries.

PEANUT BRITTLE

Inspired by Pamela Ann Kardokus, Blue Ribbon Prize
Oklahoma State Fair, Oklahoma

Peanut Brittle is a classic fair entry, and easy to make at home.

2 cups sugar

1 cup white corn syrup

½ cup water

3 cups raw peanuts

1 tsp salt

1 tbsp butter

1 tsp vanilla extract

1 tsp baking soda

Place a large cookie sheet to the side. Boil sugar, corn syrup, and water until it crackles in cold water. Add peanuts and salt. Cook on slow heat until peanuts are done. Add in butter and vanilla; stir. Add soda and stir quickly. Pour, while foaming, on large cookie sheet.

LEMON MERINGUE PIE

Debra Bond, Blue Ribbon Prize
Douglas County Fair, Roseburg, Oregon

PIE CRUST

2 cups flour

½ tsp salt

9 tbsp shortening (Crisco)

6 tbsp butter (or just enough to hold the dough together)

LEMON FILLING

1½ cups water

1¼ cups sugar

½ cup water

5 ½ tbsp cornstarch

3 egg yolks

1 lemon (juice and rind)

1 tbsp butter, room temperature

MERINGUE

3 egg whites

pinch of salt

1 cup Kraft Marshmallow Crème

Use a pastry cutter to blend the pie crust ingredients; be careful not to overwork the dough. Roll between two pieces of plastic wrap to prevent sticking. Place rolled dough in pie pan. Cook 350°F for 15 minutes or until golden brown.

For the filling: In saucepan mix water and sugar and bring to a boil. Reduce heat and add cornstarch/water mixture into saucepan, stirring constantly. Cook on low for 15 minutes or until cornstarch taste is gone. In a separate bowl crack 3 egg yolks. Once sugar/water/starch mixture is cooked, slowly add several tablespoons to yolks stirring constantly (so you don't cook scrambled eggs). Then slowly add all the egg mixture back into the sugar/water starch. Next add lemon juice and butter and cook several minutes on low until the butter is fully melted.

To make the meringue: Beat egg whites and salt until soft peaks form. Gradually add marshmallow crème, beating until stiff peaks form. Spread over pie filling, sealing to the edge of the crust. Bake at 350°F for 12–15 minutes or until lightly browned.

"My mom entered this pie and won two years in a row. The recipe came from a neighbor down the street and my mom made a few revisions on her own to make the most perfectly, tart, fluffy, crumbly lemon pie. It's another holiday favorite in our house!"

—Debra Bond

RASPBERRY PIE

Inspired by James Baum, Blue Ribbon Prize
York County Fair, York County, Pennsylvania

1 package pie crust shell
2 cups crushed fresh raspberries
1 cup sugar
1 tbsp lemon juice
2 tsp lemon zest, grated
2 tbsp cornstarch

Preheat oven to 400°F. Place 1 pie shell in the bottom of a 9-inch glass pie plate. In a large bowl, add crushed raspberries, sugar, lemon juice, lemon zest, and cornstarch and set aside for about 15 minutes. Place this mixture in pie shell, and top with second pie crust. Place pie on a cookie sheet, and make 'slits' in the top crust to prevent pie shell from cracking, or make a criss-cross lattice crust from the same ingredients. Bake for about an hour and 45 minutes till top pie shell is brown, and pie filling is bubbling from the slits in the pic crust. Cool for at least 2 hours so it can set up. It's easier to serve if it's completely cooled.

*"The raspberry pie was just a recipe I was trying because I had
so many raspberries growing in my yard and won at the same fair.
I was overrun with lots of raspberries in the garden, and didn't know
what to do with them, so I started picking them, bagged them,
and froze them till I had enough to make a few pies."*

—James Baum

LEMON BARS

Inspired by James Baum, Blue Ribbon Prize
York County Fair, York County, Pennsylvania

1 cup cake flour, sifted
½ cup butter, softened, unsalted
½ cup powdered sugar
¼ tsp kosher salt
2 eggs
1 cup sugar
2 tbsp flour or cornstarch
2 tbsp lemon juice, fresh
lemon zest, grated from 2 lemons
powdered sugar (optional)

Preheat oven to 325°F. For the crust, cream together in a mixing bowl the cake flour, butter, powdered sugar, and salt. Bake in an 8x8-inch pan in oven for 15 minutes. Once the time is up, remove crust from the oven, and set aside for 25 minutes.

Take eggs, 1 cup sugar, flour (or cornstarch), lemon juice, and zest, and place in the bowl of a stand mixer or use a handheld mixer to combine. Pour this mixture onto the crust that you have already parbaked. Place back in the oven at 325°F for 20–25 minutes till slightly brown on top. Remove, and let cool for at least 2 hours. Cut into 1x1-inch squares. Sprinkle with powdered sugar if you like.

"The lemon bar recipe was passed down to me from my great-grandmother and I won at the York Fair in York, Pennsylvania. I remember my great-grandmother making these when I would visit her in Richmond, California, with my grandmother. She would have a plate of these on the table as soon as we got to her house. She taught me to make these. My grandmother would make them for me and the rest of my family. When she passed, I lost the recipe. Luckily my aunt in California had a church cookbook with my grandmother's recipe for these. My aunt sent me the recipe, and to this day, I make these. I entered them in the fair and took home second place, then first place in 2013 at the local fair."

—James Baum

JOHNNY CAKES

Rhode Island

Finding a fair–winning recipe from Rhode Island proved to be completely elusive, however we just could not leave this historic state out! Johnny cakes (or, Johnnycakes) are a famous food from the Civil War era. They are pancake–like cornmeal flatbreads and are still popular at festivals across the state.

1 cup stone-ground yellow or white cornmeal
½ tsp salt
1½ cups milk, cold
⅛ lb butter (½ a stick), for the pan

Mix ingredients together in a medium bowl. The mixture will have a soupy consistency when complete. Heat griddle to medium. Butter the griddle thoroughly. Spoon out mixture onto griddle to make 5-inch-diameter cakes. (Mix batter well before each pouring.) Fry 2–3 minutes on each side, or until dark golden color. Remove and serve immediately with syrup and/or butter.

SNICKERDOODLES

Inspired by Nichole Reece, Blue Ribbon Prize (Cloverleaf Division)
Coastal Carolina Fair, Ladson, South Carolina

COOKIES

1 cup unsalted butter, softened

1½ cups plus 3 tbsp sugar, divided

2 large eggs

2¾ cups unbleached flour

1½ tsp cream of tartar

½ tsp baking soda

1 tsp salt

CINNAMON SUGAR TOPPING

¼ cup granulated sugar

1½ tbsp ground cinnamon

Yields 24 cookies.

Preheat oven to 350°F. In a large bowl, using a handheld or stand mixer, cream together butter and sugar until light and fluffy. Scrape down sides of bowl and add eggs until well combined. In a medium bowl, whisk together flour, cream of tartar, baking soda, and salt. Add the dry ingredients to wet, and mix until thoroughly combined.

In a small bowl, whisk together the sugar and cinnamon for the topping. Shape cookie dough by rounded teaspoonfuls into balls and roll in cinnamon-sugar mixture. Place balls 2 inches apart on baking sheets and bake for 9–11 minutes or until set. Transfer immediately onto a wire rack to cool.

CHOKECHERRY JELLY

Inspired by Janelle Reff Hudson
South Dakota State Fair, South Dakota

Used for wine, jelly, and sauces, chokecherries have a unique flavor. One of the most widespread tree species in North America, chokecherries have an astringent mouth-feel that yields to a slightly bitter taste. Despite that bitterness, chokecherries are a beloved fruit.

4 lbs ripe (black) chokecherries, stems removed; washed, drained
2½ cups water
1 (1¾ oz) box powdered pectin
4½ cups sugar
jelly bag
6 sterilized ½-pt jars

Prepare jars and lids in a dishwasher, and keep the jars hot. Mash fruit to make juice. Boil juice and water for 25 minutes over medium heat in a covered kettle pan. Use a cheesecloth bag to strain the pulp. Place 3½ cups of juice and pectin in a large kettle pan and bring this to a boil, then add the sugar, stirring constantly. Skim off the foam and stir until jelly thickens (about 2 hours). Ladle into the hot jars leaving a ¼-inch headspace. Wipe the rims of the jars with a clean cloth. Put on the lids and screw the rings to finger tightness. Simmer in a hot water bath for 10 minutes.

GREEN TOMATO RELISH

W.F. Cullum, Blue Ribbon Prize
Humphreys County Fair, Tennessee

1 qt vinegar
3 tbsp flour
3 tbsp turmeric
4 tbsp salt
1 tbsp mustard seeds
2 tbsp mixed pickling spice
2 cups sugar
4 chopped celery stems
12 chopped red sweet peppers
12 chopped green sweet peppers
1½ qt chopped onions
2½ qt chopped cabbage
2½ qt chopped green tomatoes
cloth bag

Mix a small amount of the vinegar with flour and turmeric to make a paste. Place remaining vinegar in a large kettle pan; bring to a boil. Stir in paste and let thicken like gravy. Tie spices in cloth bag. Add all remaining ingredients to vinegar mixture. Stir constantly until mixture boils; let boil 40 minutes. Place in hot 1-pint jars and seal.

PICKLED JALAPEÑO PEPPERS

Frank Speyerer, Blue Ribbon Prize
Texas State Fair, Texas

2 cups white vinegar

2 cups water

1½ lb fresh jalapeño peppers (Note: Select the best-quality peppers for canning. Choose either fresh jalapeño peppers or fresh Texas A&M mild jalapeño, and pickle as soon as possible. If you must hold them, store in a cool, well ventilated space.)

1 tsp salt to qt

½ tsp salt to pt

bay leaves (optional)

To sterilize the jars: Wash 1-pint mason-type jars in hot suds and rinse in scalding water. Put jars in a kettle pan and cover with hot water. Bring water to a boil, covered, and boil jars 15 minutes from time that steam emerges from the kettle pan. Turn off heat and let jars stand in hot water. Just before they are filled, invert jars into a kitchen towel to dry. (Jars should be filled while they are still hot.) Sterilize jar lids for 5 minutes, or as manufacturer directs.

To prepare the jalapeño peppers: Combine white vinegar and water in a medium saucepan. Bring it to a boil, lower heat and simmer while preparing the jalapeño peppers. Wash peppers, drain and slice into ¼-inch rounds, discarding stems. Note: Wear rubber gloves. If you don't wear them while you are cutting all those jalapeño peppers, your hands will absorb the juice from the peppers and burn like crazy. For a milder flavor, remove the seeds. Pack the peppers in glass jars to within ½ inch of top and cover with boiling vinegar-water, leaving a ½-inch headspace. Add salt to jars. After filling the glass jars, work the blade of a knife down the sides of the jar to remove air bubbles, and add more liquid if needed to cover peppers. Add a bay leaf to each jar if desired. Wipe ring and jar rim clean and screw on cap. Adjust lids and process in boiling water for 10 minutes. Allow jalapeño peppers to cure for a minimum of 6 weeks. Store in a cool, well-ventilated space.

"I am a New Orleans native, and when I retired from the Navy and settled in Texas, I fell in love with the state fair and the friendly Texas people. My cooking style is influenced by my Creole family … gumbo, seafood, cajun stews. I like spicy food. The Pickled Jalapeño Peppers are spiced but not just hot [for the sake of heat].

My interest in canning was encouraged in 1976 or so by a Mrs. Crowley, a lady who entered her recipes in competition and won every year. Subsequently with her encouragement, I entered several times over the years with recipes for canned tomatoes, peppers, and various other canned items. I won a lot of ribbons as did my wife of 42 years, and our son, Emerson. The best thing about the state fair is the generosity and friendship shown by the competitors, like Mrs. Crowley. My advice to anyone who wishes to can food: keep it simple and can what you will eat."

—Frank Speyerer

RED CHERRY CONSERVE-RELISH

Inspired by Travis Trittschuh, Moab, Utah
Utah State Fair, Utah

Inspired by Travis Trittschuh's Detroit conserve–style relish, this fruity, rich relish is perfect to enhance a pork or poultry dish. An English professor by trade, Travis's passion for gardening and growing fruit and vegetables has led to award–winning recipes.

3 cups pitted sour cherries, coarsely chopped
1½ cups raisins
1½ tsp ground cinnamon
½ tsp ground cloves
1 cup honey
1 cup granulated sugar
1 cup firmly packed brown sugar
1 cup distilled white vinegar
1½ cups chopped pecans
6 sterlized ½-pt jars

In a large kettle pan, combine all ingredients except pecans. Bring to a boil over medium heat, stirring constantly. Reduce heat to simmer. Cook about 2 hours or until mixture is thickened to desired consistency, stirring occasionally. Meanwhile, thoroughly wash and scald six (½-pint) jars. Prepare lids as manufacturer directs. Stir pecans into sour-cherry mixture; simmer a few minutes longer. Remove from heat. Immediately ladle into hot jars, leaving ¼-inch headspace. Wipe jar rims; seal with hot lids and screw bands. Process for 10 minutes in a simmering water bath.

APPLE CRISP

Inspired by Nathan Moore, Blue Ribbon Prize
Addison County Fair, New Haven, Vermont

I love a good apple crisp, and Vermont apples are some of the best. In the fall, Vermont is rich with leaves turning and the wonderful taste of apples made into cider, apple cider donuts, and more. For a true Vermont twist, serve with a scoop of ice cream and drizzle maple syrup on top to taste.

4 cups peeled, cored, and finely sliced tart apples
½ cup maple sugar
½ cup all-purpose flour
½ cup rolled oats
¾ tsp ground cinnamon
¾ tsp ground nutmeg
½ cup unsalted butter, room temperature

Makes 4–6 servings.

Preheat oven to 375°F. Lightly grease an 8x8x2-inch baking pan. Layer apple slices in pan. In medium bowl, combine sugar, flour, oats, cinnamon, and nutmeg. Cut in butter until crumbly. Sprinkle mixture over apples. Bake until topping is golden brown and apples are tender, about 90 minutes. Serve in bowls with a scoop of vanilla ice cream or freshly whipped cream. Top with a drizzle of Grade B Vermont maple syrup.

SUGAR COOKIES

Inspired by Dorothy McElhaney, Blue Ribbon Prize
Chesterfield County Fair & Virginia State Fair, Chesterfield County, Virginia

A classic cookie if there ever was one, the sugar cookie is a favorite because of its versatility and ability to mold into beautiful shapes. Ice the top or decorate with sprinkles, they will always delight. These cookies were made with a patterned rolling pin to create a beautiful texture on top.

4½ cups all-purpose flour

1 tsp baking powder

½ tsp salt

3 sticks (12 oz, or 1½ cups) unsalted butter, room temperature

1½ cups granulated sugar

2 large eggs, room temperature

3 tsp pure vanilla extract

1 tsp almond extract

granulated or pearl sugar, for sprinkling

Yields 48 cookies.

Whisk flour, baking powder, and salt together in a medium bowl and set aside. In a large bowl, cream together butter and sugar using a handheld mixer or stand mixer on high speed until completely smooth and creamy. Slowly add eggs, vanilla and almond extracts, and beat on high speed until combined, scraping down the sides as necessary. Carefully add dry ingredients to wet ingredients and mix until combined, on low speed. If dough seems too soft or sticky to roll out, add one more tablespoon of flour

and mix until combined. Divide the dough into two equal parts and wrap tightly in plastic wrap, pressing each ball down into a flattened round. Chill in the refrigerator for at least 1–2 hours or up to 2 days.

Lightly flour your work surface and also dust the dough with flour before rolling it out to approximately ¼-inch thick. The thicker cookie will yield a nice chewy bite once baked. If you prefer a crispier cookie, roll the dough slightly more. Cut your dough into shapes using a cookie cutter or even the open mouth of a drinking glass. If using an embossing rolling pin to print a design into your cookies, lightly run that over top of dough prior to cutting. Re-roll remaining dough until all dough has been used, but be mindful that too much handling can result in a heavier cookie.

Place cookies on a parchment paper or silicone mat–covered baking sheet, 3 inches apart. Bake for 11–12 minutes at 350°F or until lightly browned around edges. Rotate baking sheet halfway through if you suspect uneven baking. Cool cookies on the sheets before transferring to wire cooling racks. Once completely cooled, sprinkle with granulated or pearl sugar, or decorate with royal icing (recipe page 53) for a fun holiday treat.

At 99 years old "McElhaney is a vibrant, but modest woman who grew up in rural Missouri where fields and farmlands seemed to sprawl endlessly. It was a different era when neighbors were neighborly and women canned, cooked, and baked.

"One of the nice things about our family is that her [McElhaney's] mother was a great cook and the food was handed down.

"McElhaney had enjoyed going to the Springfield (Mo.) Fair as a child and continued to attend fairs into her adulthood. Her parents had never entered baked goods or stock into the fair, and neither did she, until a few years ago, when Emily Walker coaxed her into entering her sugar cookies in the Virginia State Fair. McElhaney had protested, 'Oh, no. They could look better if I cooked them special.' But, Walker prevailed, and the cookies won their first Blue Ribbon."

—The Progress Index

SPOKANE SOURDOUGH BEER BREAD

Michael Henderson, Blue Ribbon Prize
Spokane County (Interstate) Fair, Washington

2 fl oz No-Li Wrecking Ball Imperial Stout, room temperature (50 percent)

7 oz ripe levain starter (25 percent)

7⅓ fl oz water at 8°F (51 percent) plus 1¾ fl oz (2 percent)

1½ lb bread flour (75 percent)

7 oz wholewheat flour (20 percent)

1¾ oz (3⅓ tbsp) rye flour (5 percent)

1¾ oz kosher salt (2 percent)

rice flour, for dusting

Whisk stout, levain, and 7⅓ fluid ounces water thoroughly in a large mixing bowl. Add flour and autolyze (rest) for 40 minutes. Add salt plus 1¾ fluid ounces additional water. Squish with fingers until well incorporated. Final dough temperature should be 78°F.

For the bulk rise: Fold and turn seven times, 30 minutes apart. Rest on counter after last fold until bubbles form. Divide and pre-shape, then rest for 1 hour. Finish shaping and rest for 5 minutes. Dust cloth-lined proofing bowl with rice flour. Move shaped dough into bowl, seam-side up. Cover and refrigerate 20-plus hours.

Best baked in a cast-iron combo cooker or parchment-lined Dutch oven. Preheat baking vessel to 450°F. Score dough and transfer to baking vessel. Bake covered for 20 minutes. Lower heat to 400°F and bake for an additional 30 minutes. Let rest at least 1 hour before slicing.

MARSHMALLOW FUDGE

Inspired by Barbara Burner, Blue Ribbon Prize
Barbour County Street Fair, West Virginia

Fairs wouldn't be complete without fudge. When I was young I'd always rush to the counter at the fudge stand and taste samples until I was melting from an abundance of over-sweetness. This Blue Ribbon—winning recipe adds in marshmallow crème for enhanced chewy, gooey goodness.

2½ cups white granulated sugar

¾ cup (1½ sticks) butter

⅔ cup evaporated milk

12 oz package (2 cups) semisweet chocolate chips

1 jar (7 oz) jar marshmallow crème/fluff

1 tsp vanilla extract

Line an 8x8x2-inch baking dish with parchment and coat with cooking spray, set aside. In a 3-quart heavy saucepan over high heat, combine sugar, butter, and evaporated milk, and stir slowly with a wooden spoon until butter melts and all the sugar is dissolved. Continue stirring constantly as the mixture comes to a full boil. Set a timer for 5 minutes and turn down heat to medium, stirring and boiling for the full 5 minutes. Remove from heat and add chocolate chips, stirring until chips are melted and mixture is smooth. Add marshmallow crème and beat until fully combined. Add vanilla and mix well. Immediately pour into prepared pan. Let cool fully, and slice into squares for serving.

ORANGE-LEMON CITRUS BREAD

Inspired by Beverly Boettcher, Blue Ribbon Prize
Wisconsin State Fair, Wisconsin

This bread has a beautiful marbled radiant orange design. Modified from Beverly Boettcher's winning recipe, additional fruit has been added for sweetness and aesthetics. You can also add candied citrus slices (recipe page 56) to the top for a beautiful finish and serve with a dollop of fresh cream.

2 cups flour

2½ tsp baking powder

1 tsp salt

¼ cup (½ stick) butter, room temperature

1⅓ cups sugar

¼ cup vegetable oil

2 large eggs

1 tbsp grated lemon peel

1 tbsp grated orange peel

1 tsp lemon extract

1 tsp orange extract

1 can (15 oz) mandarin oranges, drained

1 cup half-and-half cream

TOPPING

¼ cup orange marmalade

1 tbsp grated lemon peel

Makes one loaf.

Preheat oven to 350°F. Line an 8½ x 4½ inch loaf pan with parchment paper. In a large bowl, combine flour, baking powder, and salt. In a medium bowl, cream butter and sugar, gradually add oil and eggs. Add dry ingredients alternately with a third dry, then half-and-half cream, then the remaining dry. Add lemon peel, orange, and lemon and orange extracts, mixing until combined, being careful not to overmix. Gently fold in mandarin oranges, pour into prepared loaf pan. Bake in preheated oven 50–55 minutes. Cool on wire rack 5 minutes.

Meanwhile for the topping, combine marmalade and lemon peel in a small microwaveable bowl. Microwave on high for 15 seconds.

Remove bread from pan to wire rack.
Spread marmalade mixture evenly over the top.
Cool completely before serving.

TRIPLE-LAYER MUD PIE

Inspired by Tracy Meats, Grand Champion Prize
Sweetwater County Fair, Rocksprings, Wyoming

The last fair that I visited was in Wyoming. The day was warm and turned into a cool night. Carnival rides lit the sky and we won at every game, carting around larger-than-life stuffed prizes, filling our faces with sticky sweets, and laughing until our sides split as the evening went on. As an adult, to have the childlike glee that comes with attending a fair is so decadent and so incredibly rare. I cherish every moment from that time, shared with friends, and look forward to many more fairs during my life.

For something else that's decadent try this pie. It is all about decadent layers, so each step creates a new layer, each with its own distinct richness and flavor.

PIE CRUST

24 chocolate sandwich cookies, including cream filling
4 tbsp melted butter

FILLING

2 squares (1 oz each) semisweet baking chocolate, melted
¼ cup sweetened condensed milk
¾ cup chopped pecans, toasted
2 cups cold milk
2 packages (3.9 oz) chocolate flavor instant pudding and pie filling
3 cups heavy cream, beaten to yield 6 cups whipped cream

For the pie crust: Pulse cookies (filling and all) in food processor into fine crumbs. Pour cookie crumbs into a medium bowl and add butter, stirring to evenly distribute. Pour mixture into a 9-inch pie dish or springform pan, and press into the bottom and along the sides to create a crust. Use the bottom of a drinking glass to create a level surface along the bottom. Refrigerate until ready to fill.

For the filling: In a medium bowl, combine melted chocolate and sweetened condensed milk, stirring until smooth and pour into prepared pie shell. Add pecans to filling, and using the back of a spatula or pancake turner, press pecans into chocolate mixture, ensuring they are mostly covered, but not floating to the bottom. Chill until set, about 10 minutes. In a large bowl, whisk milk and pudding mix until fully combined.

Gently pour 2 cups pudding mixture over pecans and chocolate in the crust. Fold half the whipped cream into remaining pudding, and spread into pie shell. Pipe or spread last of whipped cream over pie. Chill for 3 hours and refrigerate until ready to serve.

ACKNOWLEDGMENTS

I am so fortunate to work with such an incredible team. It is truly an honor to dream of something and have it come to life on the page. Images Publishing is a wonderful company with the best editors I've had the privilege and pleasure to work with in my career. I'm so grateful to Nikki, Georgia (Gina), and Honorine.

I'm forever grateful for the village who helped and supported me in this passion project and book:

Nancy Gershman, my mom, for taking me to my first county fairs, and for the beautiful watercolor drawings in this book.

Marissa Jane Miller for producing the photoshoots, recipe annotation, editing and research, assistance with prop styling, and aiding in innumerable ways! I am beyond grateful for all your help!

Chef Jennifer McMurry for cooking such wonderful food, amending recipes, and recipe development.

Suzanne Heiser for encouraging me to do this project with your recipes from home and great tales from Indiana.

Elisabeth (Bess) Schug for help with proofreading, photoshoot assistance, modeling, and more.

Sheila Johnson and family (Avery and Kylie) for location, modeling, and prop assistance.

Cherie Sexton for a beautiful location.

Toni Hunt for baking incredible pies, and Marty Hunt for help!

Paula Kornell and John Mero for tremendous support.

Deanna and Olivia Reis; Jody Vandergriff and Steve Rabkin, and Ava and Isaac Rabkin for modelling, and for opening your homes and kitchens!

Lauren, Bonnie, and Roger Preston for inspiring this book years ago in Montana.

Lu Kissner for a beautiful quilt.

Kai Moos for modeling.

Ashli Reitz for helping me at an actual county fair; the Shepard family: Ellie, Kiera, Marissa, Celia, and Bob for modeling; Lisa Devore Lombardi and kids (Mark, Ashley, Lauren) for modeling and encouragement.

Yankee Girl Antiques, Petaluma, California

Deerfield Fair: Beth Heckman

Dutchess County Fair: Debby Payne; Vicki Imperati

Nevada County Fair: Wendy Oaks

Sonoma County Fair: Sheila Quince; Tim Tesconi; Tawny Tesconi; Teejay Lowe

Spokane County (Interstate) Fair: Jessie McLaughlin

Images Publishing: Honorine Le Fleur; Georgia (Gina) Tsarouhas; Nicole Boehringer

RESOURCES AND CREDITS

Fair staff assistance: Beth Heckman
Deerfield Fair: Ken Heckman; E. Kingston
Dutchess County Fair: Debby Payne; Vicki Imperati
Nevada County Fair: Wendy Oaks
Sonoma County Fair: Sheila Quince, Tim Tesconi, Tawny Tesconi, Teejay Lowe
Spokane County (Interstate Fair): Jessie McLaughlin

Blue Ribbon Recipes: County Fair Winners. The Cookbook Collectors Library: 1968
www.mostatefair.com
www.nevadacountyfair.com
https://www.boltonfair.org/about-us
https://www.montanafair.com/p/more/about/montanafair-history
https://abcnews.go.com/US/25-state-fairs-drivers-local-economies-canceled-postponed/story?id=71437342
https://sangamoncountyhistory.org/wp/?p=1389
www.washingtonpost.com/archive/lifestyle/food/1997/08/27/stars-of-the-state-fair/a43823d3-cfeb-46af-b34d-1f4afac4404a/
https://www.tampabay.com/archive/1998/01/30/cookbook-to-feature-50-years-of-fair-recipes/?outputType=amp
https://www.cnn.com/2020/08/31/us/state-fair-drive-thru-coronavirus-2020-trnd/index.html

All images by Liza Gershman, excluding the following:

CreatewithClaudia / shutterstock.com *[vintage quilt]* 169
eriyalim / shutterstock.com *[vintage quilt]* 103
Nancy Gershman *[watercolor drawings]* 6, 10, 32, 44–45, 58–59, 216
Steve Mann / shutterstock.com *[gingham prints]* 9, 123, 137, 207 (*inspired by Steve Mann:* 89, 95, 99, 115, 129, 143)
mama_mia / shutterstock.com *[gingham prints]* 6–7, 48, 49, 52, 53, 54, 56, 57, 220–23, endpapers, back cover (*inspired by mama_mia:* 218–19)
Linda Robertus / shutterstock.com *[original vintage quilts]* 79, 140, 151 (*inspired by Linda Robertus:* 199)

Recipes amended by Jennifer McMurry:
Angel Food Cake
Apricot Bars
Black Raspberry Bubble Ring Cake
Blueberry Lattice Bars
Chewy Pecan Bars
Chip Chocolate Chippers
Classic Apple Pie
Cream Cheese Frosting
Devil's Food Cake
Italian Meringue
Key Lime Pie
Lemon Bars
Peach Raspberry Pie
Peach-Orange Pie
Peanut Butter and Jam Bars
Raspberry Cream-filled Cake
Raspberry Pie
Seven-Minute Frosting
Southern Layer Cake / Prize Cake
Triple Chocolate Rebel Cookies

Recipes amended by Marissa Jane Miller:
Apple Cake
Apple Crisp
Buttermilk Biscuits
Buttery Peach Toffee Pie
Candied Citrus Slices
Candied (Glazed) Pecans
Coconut Cake
Gingersnaps
Glaze
Golden Spice Cake with Orange Butter Frosting
Graham Cracker Crust
Marshmallow Fudge
Orange Chiffon Cake
Orange-Lemon Citrus Bread
Peach Cobbler
Pie Dough
Pina Colada Cream Pie
Rhubarb Cake
Rhubarb-filled Cookies
Simple Syrup
Snickerdoodles
Strawberry Lilies
Sugar Cookies

Triple-Layer Mud Pie
Vanilla Cake and Buttercream Frosting
Whipped Cream
Zucchini Brownies

Models pictured on the following pages:
18: Celia and Bob Shepard; 24: Kayla Jones Walker; 25: Lindsey and Logan Reed; 43: Lauren Lombardi; 46–47: Ellie, Celia, Kiera, and Marissa Shepard; 68: Kylie Johnson; 81: Marissa Jane Miller; 83: Marissa Shepard; 85: Kai Moos; 90: Bonnie and Lauren Preston; 91: Olivia and Deanna Reis; 97: Avery Johnson; 102: Marissa Shepard; 114: Ellie, Celia, Kiera, and Marissa Shepard; 122: Margaret and Elizabeth Jorgensen; 141: Ashley Lombardi; 165: Isaac Rabkin; 168: Mark Lombardi; 171: Annabelle and Bernadette Cardin; 181: Bess Schug; 213: Kai Moos; 214: Nancy and Liza Gershman; 215: Isaac and Ava Rabkin

INDEX

Liza Gershman | Best-selling author and Winner of the Gourmand Cookbook Award (2018), Liza has published nineteen books, including *Nantucket*, and *Cuban Flavor*, which was touted on CBS, National Geographic, Travel & Leisure, NPR, and more. Liza was honored to speak for 'Talks At Google,' and on the prestigious campuses of Twitter, Oracle, and Disney. Clients: Williams-Sonoma, Goldman Sachs, Hyatt Hotels, Restoration Hardware, Getty Images, AirBnB, Visa. In 2010, Liza was Governor Jerry Brown's campaign photographer, and in 2014 was a photographer for America's Cup. She's photographed in more than 55 countries and 47 states. She specializes in creative direction, art direction, styling, writing, and photography.

Published in Australia in 2021 by
The Images Publishing Group Pty Ltd
ABN 89 059 734 431

Offices

Melbourne
6 Bastow Place
Mulgrave, Victoria 3170
Australia
Tel: +61 3 9561 5544

New York
6 West 18th Street 4B
New York, NY 10011
United States
Tel: +1 212 645 1111

Shanghai
6F, Building C, 838 Guangji Road
Hongkou District, Shanghai 200434
China
Tel: +86 021 31260822

books@imagespublishing.com
www.imagespublishing.com

Copyright © Liza Gershman 2021
The Images Publishing Group Reference Number: 1614

A catalogue record for this book is available from the National Library of Australia

Title: County Fair: Nostalgic Blue Ribbon Recipes from America's Small Towns // Liza Gershman
ISBN: 9781864709179

This title was commissioned in IMAGES' Melbourne office and produced as follows: **Art direction/production** Nicole Boehringer, *Senior editorial* Georgia (Gina) Tsarouhas, *Proofing* Jeanette Wall

Printed by Graphius nv, Belgium, on 150gsm Condat Matt Périgord art paper

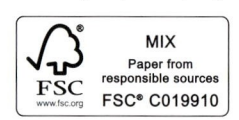

IMAGES has included on its website a page for special notices in relation to this and its other publications. Please visit www.imagespublishing.com